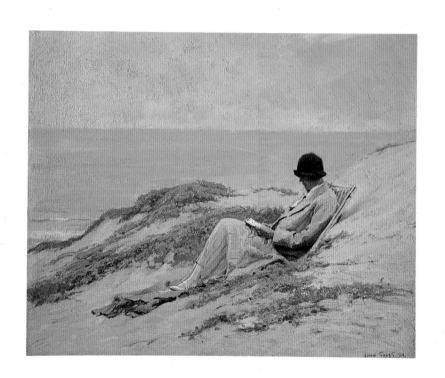

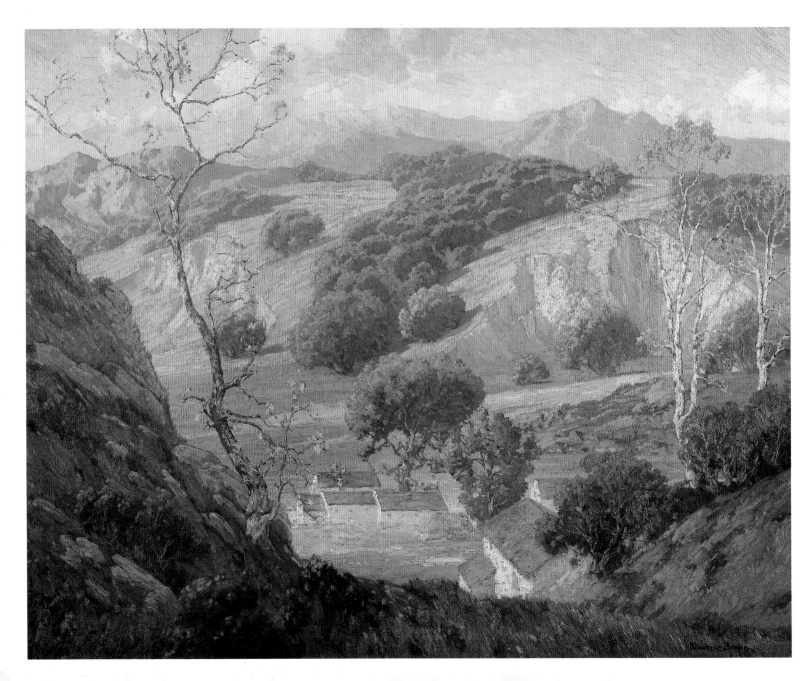

PAINTINGS OF
CALIFORNIA

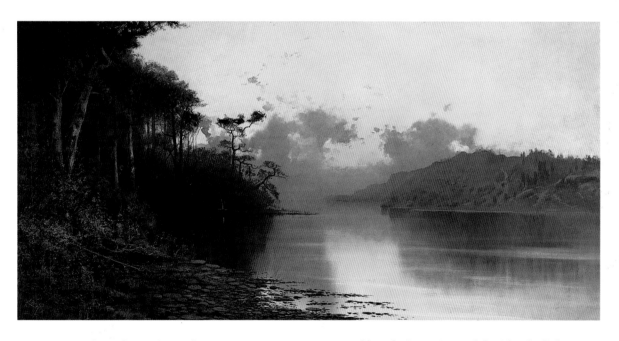

Introduction by Ilene Susan Fort • Edited by Arnold Skolnick

UNIVERSITY OF CALIFORNIA PRESS
BERKELEY • LOS ANGELES • LONDON

University of California Press
Berkeley and Los Angeles, California

University of California Press Ltd.
London, England

Published by arrangement with
Chameleon Books, Inc.

Copyright © 1993 by Chameleon Books, Inc.
Text copyright © 1993 by Ilene Susan Fort

First California Printing, 1997

Produced by Chameleon Books, Inc.
211 West 20th Street
New York, New York 10011

Production director / designer: Arnold Skolnick
Jacket design: Howard Klein
Composition: Larry Lorber, Ultracomp, New York

Library of Congress Cataloging-in-Publication Data

Paintings of California / Introduction by Ilene Susan Fort : edited by
 Arnold Skolnick.
 p. cm.
 Originally published: New York : C. Potter, 1993.
 Includes bibliographical references.
 ISBN 0-520-21252-5 (cloth; alk. paper). — ISBN 0-520-21184-7 (pbk. ;
alk. paper)
 1. California — In art. 2. California — In literature.
 3. Landscape painting. American. 4. Landscape painting — 19th
century — United States. 5. Landscape painting — 20th century. — United
States. I. Skolnick, Arnold.
 [ND1351.5.P36 1997] 97-14015
758'.1794'0973 — dc21 CIP

The paper used in this publication meets the minimum requirements of
American National Standard for Information Sciences — Permanence of Paper
for Printed Library Materials ANSI Z39.48 – 1984.

Printed and Bound by O.G. Printing Productions, Ltd., Hong Kong

 1 2 3 4 5 6 7 8 9

(half-title page)
John Frost, Artist's Wife, 1924
Oil on board, 18 x 22 inches

(frontispiece)
Maurice Braun, California Valley Farm, 1920
Oil on canvas, 40 x 50 inches

(title page)
Julian Rix, Upper Sacramento River, c. 1876
Oil on canvas, 30 x 60 inches

Acknowledgments

From THE REVOLT OF THE COCKROACH PEOPLE by Oscar Zeta Acosta. Copyright © 1989 by Oscar Zeta Acosta. Reprinted by permission of Vintage Books, a division of Random House, Inc.

From AMERICA, Copyright © 1986 by Jean Baudrillard. Reprinted by permission of Verso / NLB, London and New York.

From "IT NEVER RAINS IN SOUTHERN CALIFORNIA" BY ALBERT HAMMOND & MIKE HAZELWOOD © 1972, 1973 EMI APRIL MUSIC INC. All rights reserved. International Copyright Secured. Used by permission.

From THE SELECTED POETRY OF ROBINSON JEFFERS by Robinson Jeffers. Copyright 1924 and renewed 1952 by Robinson Jeffers. Reprinted by permission of Random House, Inc.

From BIG SUR Copyright 1962 by Jack Kerouac. Reprinted by permission of Sterling Lord Literistic, Inc.

From SOUTHERN CALIFORNIA COUNTRY: AN ISLAND ON THE LAND. Copyright © 1946 by Carey McWilliams. Reprinted by permission of Gibbs Smith, Publisher; Peregrine Smith Books.

From Henry Miller: BIG SUR AND THE ORANGES OF HIERONYMUS BOSCH. Copyright © 1957 by New Directions Publishing Corporation. Reprinted by permission of New Directions Publishing Corporation.

From JOURNEY TO NOWHERE by Shiva Naipaul. Copyright © 1980, 1981 by Shiva Naipaul. Reprinted by permission of Simon & Schuster, Inc.

From Kenneth Rexroth: THE COLLECTED SHORTER POEMS OF KENNETH REXROTH. Copyright 1940 by Kenneth Rexroth. Reprinted by permission of New Directions Publishing Corporation.

From Louis Simpson, AT THE END OF THE OPEN ROAD, "Lines Written Near San Francisco," copyright © 1963 by Louis Simpson. Wesleyan University Press by permission of University Press of New England and the author.

From Louis Simpson, ADVENTURES OF THE LETTER I, "The Climate of Paradise," Copyright © 1971 by Louis Simpson. Reprinted by permission of Harper Collins, Inc. and the author.

"Excerpts as provided", from THE RED PONY by John Steinbeck. Copyright 1933, 1937, 1938 © renewed 1961, 1965, 1966 by John Steinbeck. Used by permission of Viking Penguin, a division of Penguin Books USA Inc.

From EAST OF EDEN by John Steinbeck. Copyright 1952 by John Steinbeck, © renewed 1980 by Elaine Steinbeck, John Steinbeck IV and Thom Steinbeck. Used by permission of Viking Penguin, a division of Penguin Books USA Inc.

This book would not have been possible without the assistance of the staffs of the various museums, art galleries and commercial dealers represented herein and to the many private collectors who agreed to share their paintings with the general public. I am especially grateful to George Stern and Whitney Ganz for their assistance in locating paintings.

I wish to thank my friend and colleague, Dr. Patricia Trenton, curator of the Los Angeles Athletic Club, and my husband, Gustavo Botvinikoff, for reading early drafts of my essay. Their comments and suggestions proved most beneficial. I am also indebted to Professor William Gerdts, whose writings in American art and seminal work on regionalism have long provided me with an outstanding exemplar. Thanks go to Lynn Schumann of Chameleon Books for her conscientious administrative assistance and to Arnold Skolnick for providing me with the opportunity to share my thoughts about California art and culture with the reading public.

Listening to the music of the Beach Boys was my first introduction to California. So I would like to dedicate my essay to all those fellow teenage dreamers of the 1960s and 1970s.

Ilene Susan Fort

Chameleon Books wishes to thank all the public institutions who have supplied the wonderful images found in this book. We are especially indebted to Harvey Jones from The Oakland Museum.

We are grateful to all the galleries for their assistance, with special thanks to: Contemporary Realist Gallery; Montgomery Gallery; Spanierman Gallery; Modernism; Garzoli Gallery; Koplin Gallery; Maxwell Galleries, Allan Stone Gallery, George Stern Fine Arts, and Tatistcheff Gallery. Our special thanks to David Stary-Sheets from the Stary-Sheets Gallery and Alfred Harrison from The North Point Gallery.

Thanks also to all the private collectors, including Gordon T. McClelland, The Buck Collection, The E. Gene Crain Collection, James and Linda Ries, Joseph L. Moure, Sally and David Martin, Eldon Grupp, Dr. and Mrs. Edward H. Boseker, Drs. Ben and A. Jess Shenson, James Delman, Mr. & Mrs. Robert E. Aichele, Paula and Irving Glick, and Nancy Boas, author of *The Society of Six: California Colorists*.

We are indebted to James L. Coran and Walter A. Nelson-Rees, who supplied us with images from the collection of California painting that was tragically destroyed by the Oakland fire in 1991.

To all the artists who submitted their wonderful work to us, including so much of which we regretfully did not have room to include, thank you.

Special thanks to Ilene Susan Fort, who was an immense help in every way; to Nancy Crompton; and to Carl Sesar for his careful editing.

Arnold Skolnick

Contents

I N HIS ANSWER TO A SEEMINGLY STRAIGHTFORWARD QUESTION ABOUT HIS BACKGROUND, THE NORTHERN CALIFORNIA PAINTER GOTTARDO PIAZZONI EPITOMIZED THE SPELL CALIFORNIA HAS CAST ON ITS ARTISTS. FOR OVER 150 YEARS, THOUSANDS OF VISITING AND RESIDENT PAINTERS HAVE BEEN MESMERIZED BY

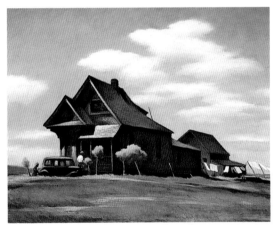

the coast, the redwood forests, the mountains and deserts of the thirty-first state of the Union.

The California mythology was born out of and encouraged by the Spanish legend of El Dorado—the land of gold. Euro-Americans, Mexicans, and Asians migrated to California in quest of a prosperous future. The environment encouraged success—a mild climate most of the year with an ever-present sun and warm gentle breezes. The land was open, fertile, and seemingly available—California Indians having greatly declined in numbers due to disease brought by the first Europeans. By the late nineteenth century, California had come to symbolize in the minds of most Americans the dream of a comfortable and healthy life. The myth prevailed for a century and artists were not only its witnesses, but on many occasions its promoters.

During the Depression, writers such as John Steinbeck, Upton Sinclair, Mary Austin and Nathanael West wondered whether the dream had failed, but most painters continued to glorify California as a land of beauty and opportunity. Some did occasionally hint that something was awry through their use of surreal imagery. But such interpretations merely added another level of fantasy to the vision and were quite in keeping with the dreamworld that the film industry was then creating in Hollywood—the town L. Frank Baum, author of *The Wizard of Oz*, referred to as "the land of enchantment."

In reality, the myth of California had long been under attack by actual developments. Los Angeles had emerged as a boom town in the beginning of the century as its population soared. Land development became one of the primary businesses in southern California, dominated by the people who owned the railroads and ran the chambers of commerce and the businesses and institutions profiting from the rapid growth. As World War II brought workers to shipbuilding and aircraft

EMIL JEAN KOSA JR., Untitled (Farmhouse), n.d., Oil on canvas, 22 x 28 inches

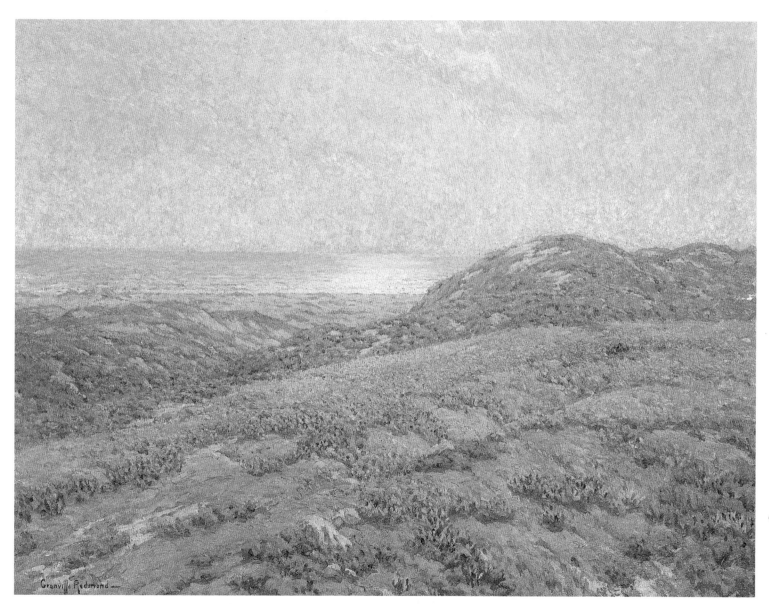

GRANVILLE REDMOND, Silver and Gold, n.d., Oil on canvas, 30 x 40 inches

manufacturing jobs and soldiers and sailors to bases in California, the wartime and postwar population exploded. Endless tract housing for the newcomers contributed to the demise of the citrus industry. Coastal truck farms once owned by Japanese Americans relocated during the war were absorbed into growing towns. After World War II, continuing immigration, extensive urban sprawl, and development of high technology industries added new stresses, and by the 1960s environmentalists realized the necessity to slow down development, as California's boundless sky was sullied by persistent air pollution and water sources suffered depletion. Yet, in the minds of artists the California dream was so potent that not until recent decades did contemporary paintings hint that paradise was threatened.

In the mid-1890s, artist John Gutzon Borglum explained that artists were attracted to California because "such pure and living color is found in but few parts of the world, and such variety of strange and 'paintable' matter does not exist elsewhere." He went on to note that an intangible element also played an essential role in enchanting the imagination: "The marvelous has always been associated with this State. The same strange charm still exists that attached to California in the first Spanish exploration. Its history teems with romance and picturesqueness."

Artists wandered to many remote places for the uniquely Californian subjects and "marvelous" atmosphere. Yet they tended to establish their studios in what would become the three major metropolitan centers: initially San Francisco, then by the end of the century, Los Angeles, and shortly thereafter, San Diego. Painters also congregated on weekends in smaller towns and villages, in particular at coastal sites such as Carmel, Laguna Beach, and Santa Barbara. The retreats often evolved into summer colonies, occasionally with prominent artists such

as George Bellows, William M. Chase, Childe Hassam, and Gardner Symons visiting from the East. Ultimately these places grew into year-round art communities of national prominence.

In January 1848, less than a month before the United States took possession of California from Mexico, deposits of gold were found at Sutter's Mill on the American River in northern California. Within five years 300,000 people from the East Coast and abroad had come to seek their fortune. Among the new arrivals were artists. Some were commercial illustrators on assignment for national journals, but others came seeking wealth. For painters such as Charles Nahl and Ernest Narjot, artistic abilities proved more profitable than prospecting. With firsthand knowledge of mining practices they expertly documented the prospectors' panning for the precious metal. In *Miners in the Sierras*, Nahl and Frederick A. Wenderoth showed men working a placer, a deposit of gold found loose in sandbars and gravel banks. Such frontier mining paintings differed from the utilitarian and religious art produced earlier in California by the native Indians, Spaniards, and Mexicans: they were the earliest genre scenes (narratives about everyday life) painted in California. So popular were these images in scenes of the 1850s and 1860s that the robust and adventuresome miner came to symbolize the region, becoming the first hero of the newly conquered American territory, the California equivalent of the Western cowboy. Cowboys and Indians only sporadically appeared in local scenes and, in this respect, the painters of California did not adhere to the standard myths of the West.

However, it was the primacy of the land that attracted the first visitors and, until recently, the landscape continued to be the principal magnet that drew artists here. As a result, the term "California Painting" has usually signified landscape painting. Geographically, California covers almost 160,000

square miles and is the third largest state in the Union. Its scale partly accounts for the variety of terrain: from the soaring mountain ranges of the Sierra Nevada and the arid Mojave Desert and Death Valley on the east, through the majestic forests of Yosemite and Sequoia and the fertile valleys of Napa and the Sacramento and San Joaquin rivers, to the rocky coast of Monterey and the sandy beaches of Santa Barbara and La Jolla on its western shore.

The first landscape views were mainly watercolors and drawings created by visitors, often amateur artists, who came with explorers and official government expeditions. Typical were the accurately detailed watercolors James Madison Alden painted of headlands, bays, and estuaries he saw while a member of the Pacific Coast Survey unit in the 1850s. After accompanying the famed scout Kit Carson over the Old Spanish Trail, George D. Brewerton went beyond conveying the elemental forces of the scorching desert in *Jornada del Muerto,* a haunting view of the Mojave Desert somewhere

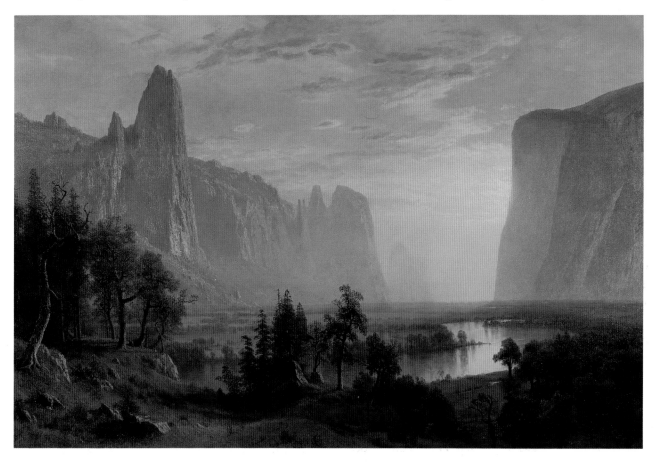

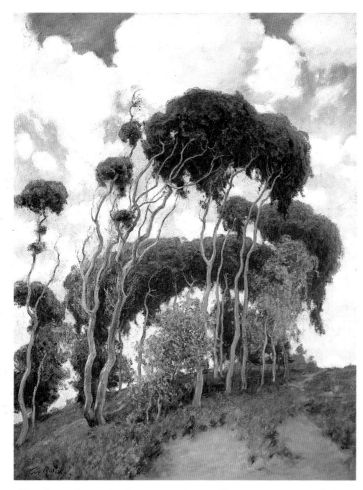

GUY ROSE, Laguna Eucalyptus, c. 1916-1917, Oil on canvas, 39½ x 30 inches

between Bitter and Resting Springs. The all-pervasive sun in his scene is the instrument of death, an idea atypical for California paintings. The state's artists have demonstrated less of a propensity for painting the desert than did their counterparts in New Mexico and Arizona. And when artists such as Fernand Lungren and Conrad Buff did specialize in the desert, rather than hint at its more destructive character, they revealed an understanding of this special ecosystem and conveyed its beauty and sublimity with a sense of awe.

Artists were enchanted by the unspoiled, startling vistas of the northern Sierras, in particular Donner Pass, Lake Tahoe, Mount Whitney, and Yosemite Valley. Yosemite's vertically soaring walls and peculiar granite formations made the valley a geologic wonder. Miwok Indians had lived in the valley since 1000 B.C., but not until the mid-1850s was it explored and sketched by Euro-Americans. In 1863, geologist Clarence King made his initial visit, as did noted landscape painter Albert Bierstadt. Magazine and newspaper articles and illustrations acquainted Americans back in the East and Midwest with its unique topography and inspired tourists to visit. Yosemite came to signify the grandeur of California. Bierstadt established his fame with dramatically lit and meticulously rendered views of the valley, which he composed back in his New York studio from sketches made in the field. He painted the region at the height of its color and vegetation, sometimes with brilliant sunsets of orange and gold, and in winter all snow-covered and solitary.

During the settlement of the eastern seaboard, the rugged hinterland of the United States was extolled by writers, preachers, and artists as a paradise. With the passage of time and the establishment of communities in the Midwest, the Pacific Coast region came to represent the last of the frontier. Upon reaching Yosemite, Bierstadt wrote to his friend John Hay, "We are now here in the garden of Eden....The most

magnificent place I was ever in." The majestic mountain range of the Sierras was truly a heavenly paradise. It epitomized the idea of divine immanence espoused by the New England Transcendentalists that had become central to the American concept of nature. However, the region offered not only breathtaking visions, but a rich, almost untouched realm of natural resources as well. Economic factors underlaid, and to a large extent determined, the doctrine of Manifest Destiny. Indeed, the West's seemingly infinite potential had been a strong rationale in legitimizing American expansionist politics. Fortunately, artists, scientists, and journalists who visited the area realized the potential threat to the natural wilderness of widespread settlement and commercial exploitation. Consequently, they played a significant role in protecting this unique environment. The nationwide conservation movement of the late nineteenth century received its strongest impetus in California through the writings of John Muir, a naturalist who first visited Yosemite in 1868 and in 1892 established the Sierra Club. Two years earlier, in 1890, Yosemite Valley, Kings Canyon, and Sequoia were established as national parks.

It was inevitable that California's distinctive flora would dominate the imagination of many painters. The redwood and big tree, two species of the sequoia, a giant evergreen, aroused the most amazement. Their gigantic scale came to signify the immensity and surreal quality of California, just as the valley of Yosemite had. The mammoth trees quickly attracted tourists, as indicated by the host of paintings which depict visitors ambling through California forests. The sublime height of the sequoia eventually encouraged a new painting format. In the 1890s, Thomas Hill used extremely narrow vertical canvases (their height was over three times greater than their width). The soaring Monterey pine, the Monterey cypress twisted by the coastal wind, and the scrub oak in the chaparral also identify the state in painted views. Imported

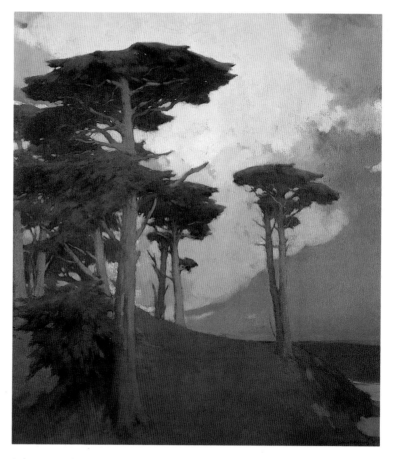

ARTHUR F. MATHEWS, Monterey Cypress #3, 1933, Oil on canvas, 38¼ x 34¼ inches

from Australia in the 1850s, the eucalyptus with its slender trunk and small, delicately tinted leaves had been planted as a windbreaker so often that by the end of the century it had altered the look of southern California. Its frequent appearance in twentieth-century landscapes of the region led the critic Merle Armitage in 1928 to dub them "The Eucalyptus School." Also imported, palms appeared in early twentieth-century landscapes. Only recently however, has the palm tree become a popular emblem, signifying the region's tropical character, in both commerical advertisements and contemporary paintings.

The image of California as a floral garden was also strongly associated with the southern region. During the early decades of this century, artists like Granville Redmond captured the carpets of brilliantly colored wildflowers, in particular buckeyes, lupines, and poppies, that cover the hillsides in springtime. Real estate promoters encouraging the settlement of southern California often alluded to its similarities with the Mediterranean, conveying the idea of a semi-tropical bourgeois utopia centered around an easy style of outdoor living. Painters responded by depicting people relaxing in gardens and patios, and gathering flowers, continuing the myth of a natural paradise even when the environment was threatened by urbanization. Actually, nature in arid southern California was to a large extent man-made, many of its plants having been imported and irrigated with water from the north. In his landmark 1946 book on the region, Carey McWilliams noted this and went on to explain the illusion:

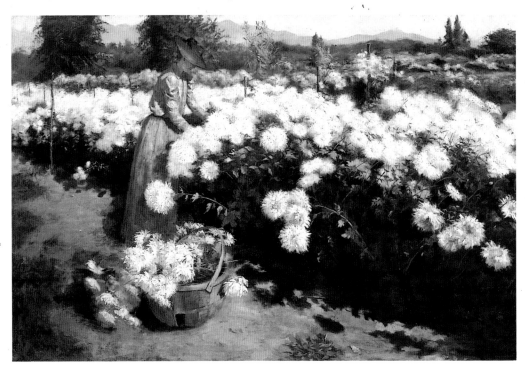

Fannie Eliza Duvall, Chrysanthemum Garden in Southern California, 1891, Oil on canvas, 42 ½ x 68 ¼ inches

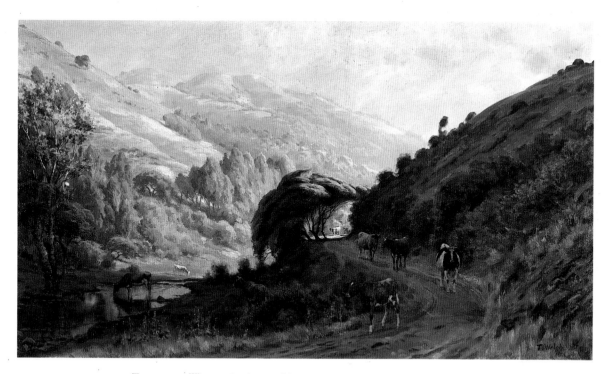

THADDEUS WELCH. Landscape with Cows, 1906, Oil on canvas, 20 x 36 inches

"The land has a certain air of unreality and impermanence. ...One does not question the display of exotic flowers and trees, the palms and gigantic hedges; ... but all the time there is a sense of having strayed into one of Mr. Wells' Utopias."

California offered not only unspoiled natural splendors, but a bounty of rich virgin land to cultivate. In 1769, upon crossing the Los Angeles basin, Fra Juan Crespi wrote in his diary, "All the soil is black and loamy and is capable of producing every kind of grain and fruit which may be planted." The Franciscans used local Indian labor to grow fruits and vegetables on the land around the missions, while later on Mexican rancheros raised long-horned cattle. Only with the discovery of gold did farmers come in great numbers, and with their arrival the valleys, alluvial plains, and rolling hillsides of California were subjected to cultivation. The Sacramento River area and the Napa Valley were among the first to be farmed because they were not far from the mines and offered unsuccessful prospectors an alternative means of support.

The region was truly "the promised land" and its frontier image quickly diminished as crops were planted. Gold fields of wheat soon replaced the sparkle of yellow metal as the symbol of California. Cattle ranching, vineyards, and the fruit industry prospered. Harvest scenes became popular in painting as artists extolled the virtues of a bucolic agrarian society. So productive was the land that between 1880 and 1920

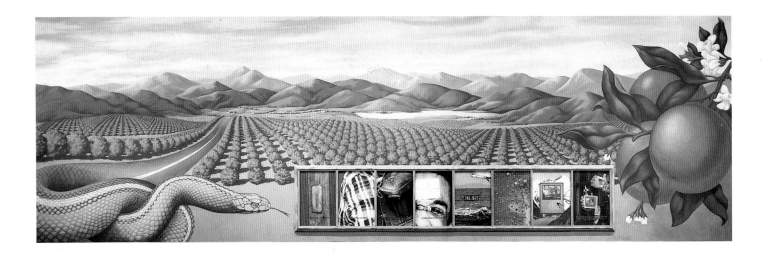

California developed into an agricultural empire. Despite the high degree of mechanization of California farms, however, painters only infrequently extolled technological advances. As late as the 1910s, Thaddeus Welch continued to portray the cattle industry with pastoral landscapes of steer grazing on the gentle slopes of Marin County.

In the first two decades of this century, advertising campaigns throughout the country promoted the health benefits of California oranges. The citrus industry became so identified with the state that orchards and blossoming fruits appeared in art whenever an easy visual reference to California was required, as seen in New Deal projects of the 1930s when muralists were commissioned to depict local events and industries on the walls of public buildings. Contemporary artists, such as Alexis Smith in her 1987 mixed-media installation, aptly entitled *Same Old Paradise,* continue to use citrus fruit as a metaphor for California, the land of sunshine and health, though tract housing has replaced most citrus groves.

In addition to the mountains and inland valleys, the coast has been a potent force and inspiration. It so dominated the first legends about the region that the earliest maps depicted California as an offshore island! The coastal area is not only where most residents have lived and worked (and still do), but is one of the world's most widely praised and frequently visited tourist attractions. The ocean, shore, and bays were originally places of communication and business, as many paintings demonstrate. Artists focused on the maritime vessels that transported new immigrants and supplies from distant ports to San Francisco, and on longshoremen and fishermen who worked on the wharves.

Only around the turn of the century did artists begin to appreciate the coast primarily for its aesthetic beauty. They still painted harbors with their wharves and boats, implying the continuation of the fishing industry, but gave little attention to commercial enterprise; Armin Hansen alone sang the praises of fishermen. The plethora of paintings of the sea and adjoining shore affirm the overwhelming mystique of the Pacific Ocean. Many artists preferred to dwell on the solitary

ALEXIS SMITH, Same Old Paradise, 1987, Mixed media installation, 20 x 60 feet

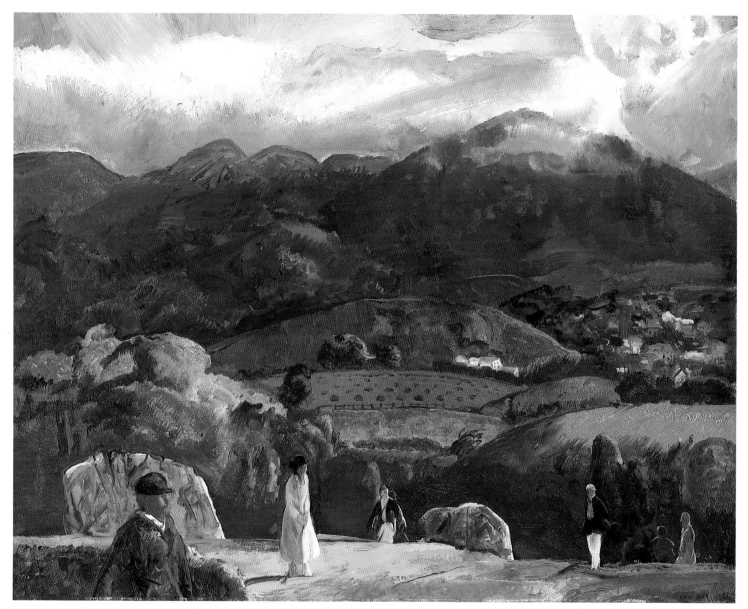

GEORGE BELLOWS, Golf Course—California, 1917, Oil on canvas, 30 x 38 inches

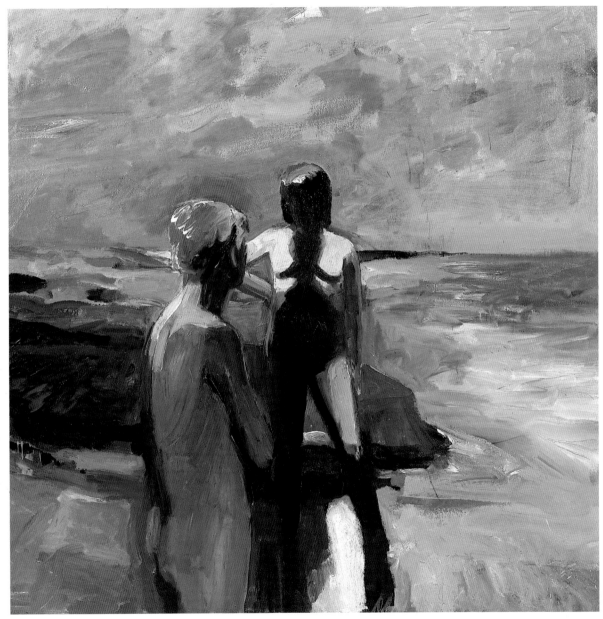

ELMER BISCHOFF, Two Figures at the Seashore, 1957, Oil on canvas, 56 x 56¾ inches

nature of the California coast in the tradition of Winslow Homer's Maine seascapes. Hundreds of paintings of the Monterey Peninsula attest to the beauty of this rocky shoreline and the elemental power of the ocean with its breakers continually pounding the cliffs, spraying the land and air. Arch Beach, Dana Point, and Laguna Beach to the south were equally appealing, although artists usually interpreted these scenic spots in gentler terms.

The beaches have also served as a favorite recreational area, perfect for the leisurely lifestyle of southern California. In the early decades of this century swimming became a popular sport and a subject for painters. While some eastern artists, such as Chase and Robert Henri, focused on individuals resting on the sand, and others depicted bathers, California painters usually conceived of the frolickers as large crowds in distant views of the shore. By the 1920s and 1930s sunbathing had become such a favorite urban pastime that the beaches of Los Angeles were crowded with people. Consequently, among the prosaic activities depicted in genre painting of the period were people enjoying the seashore. At the same time, many artists found the interaction of the sun, sand, and water a perfect subject for exploring the translucent, light-based medium of watercolor.

By the 1960s, the hedonistic lifestyle that the California shore supposedly had spawned was glorified in the highly successful beach party and *Gidget* movies. The popular rock groups of Jan and Dean and the Beach Boys extolled the life of the surfing culture; the rapid spread of the sport from Malibu to Laguna Beach was the theme of the Beach Boys' "Surfin' Safari," while in "Do It Again," they sang about the pleasures of California girls, the sun, and surfing. Despite the incorporation of the California beach myth into popular culture, contemporary painters generally have avoided the theme. However, in David Hockney's paintings the private swimming pool has become an icon signifying the luxurious lifestyle of the California dream.

A large expanse of sky usually crowned the mountain and coast scenes. In northern California, artists investigated various atmospheric conditions during different seasons, times of day, and kinds of weather. Toward the end of the century, Arthur Mathews and other artists from San Francisco began explor-

GUY ROSE, Mist Over Point Lobos, c. 1918, Oil on canvas, 28½ x 24 inches

ing the Monterey Peninsula. Influenced by George Inness, a noted eastern landscape artist who had visited the area in 1891, they rejected the meticulously delineated scenic views of earlier landscapists for the more poetic interpretations of French Barbizon painting. The artists conceived of the region in terms of a limited palette of soft, quiet tones that underscored the solitary nature of this sparsely inhabited region. Their views of the coast and inland hills showed how the dampness of the ocean filled the air with cold moisture and how the fog rolling in obscured any view of the craggy bluffs and solitary houses.

While tonalism was in keeping with the rural character of the Monterey Peninsula, the paintings of the later, modernist Society of Six group were about the experience of nature in the twentieth century. Encouraged by French Impressionism and Post-Impressionism, Selden Gile, Louis Siegriest, and other members of the Society created brilliantly hued, expressionist renderings of the docks, hills, and quaint neighborhoods of Oakland that literally sing with the joys of simple town life. They favored the midday sun or the bright overcast light so typical of the Bay Area. Their clear, brilliant illumination and glowing palette prefigured the canvases of Elmer Bischoff, David Park, and other Bay Area painters of the 1950s.

In contrast to their northern counterparts, artists in the southern half of the state became almost obsessed with the relentless power of the sun. This region did offer seemingly ideal weather conditions. Mary Austin underscored this in her novel *The Land of Little Rain* (1903). Earlier, Charles Loomis promoted in his aptly titled magazine, *Land of Sunshine,* the benefits of physical and mental well-being that easterners and midwesterners would experience by moving to southern California. And thousands listened, among them

author Charlotte Perkins Gilman, who settled in Pasadena in 1888 to recover from a breakdown and recorded her experience: "There was the nerve-rest of steady windless weather. . . . Never before had my passion for beauty been satisfied. The place did not seem like earth; it was paradise." The belief in the eternal sun and its soothing nature has remained a constant throughout the decades. While in New York during the winter of 1965, John Phillips of the Mamas and the Papas wrote the rock-and-roll song "California Dreamin'," expressing his longing for the safety and warmth of Los Angeles.

In 1917, critic Antony Anderson noted that southern-California artists had recently demonstrated an increasing fascination with light and air, an interest that the French Impressionists first promoted. By the second decade of this century, a significant number of painters in the region were identified with Impressionism. The return of Guy Rose to his hometown of Los Angeles in 1914, after many years in Giverny, France, where Claude Monet lived, added a spark to this development. Artists such as William Wendt and Joseph Kleitsch moved their easels out-of-doors so that while they were painting they could experience firsthand the wind blowing through the trees and the sun burning its warm air over rolling hills. California *plein-air* painters, as they came to be known, were more concerned with conveying these sensations than delineating the actual details of flora and terrain. Critic Arthur Millier attributed this interpretation to the effect of the region itself.

The Impressionists idealized southern California weather into one perpetual clear, sunny day. Earlier landscapists had indicated that conditions were actually quite varied: instead of a blazing sun, clouds sometimes filled a delicately tinted blue sky, or a white vapor formed and floated over the basin

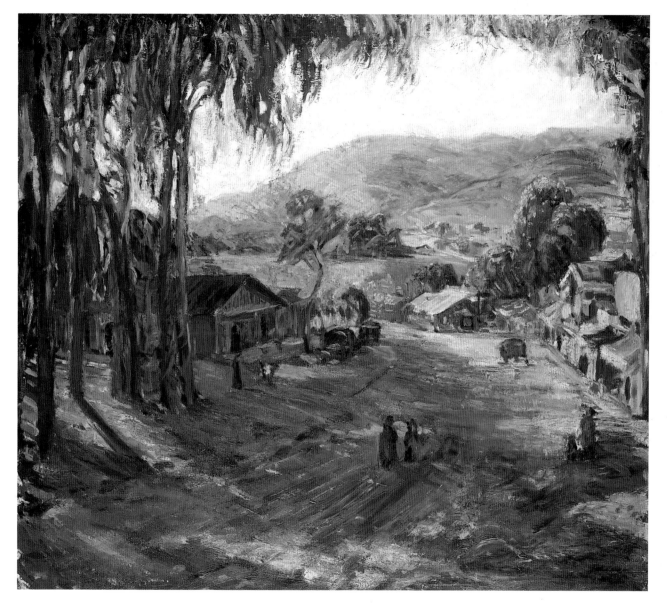

JOSEPH KLEITSCH, Old Laguna, 1924, Oil on canvas, 36 x 40 inches

of Los Angeles. But not until contemporary painting did a more accurate portrayal resurface. Now during many days in the Southland, the sun must, unfortunately, filter through a cloudy, yellowish haze, which is no longer natural condensation, but rather pollution. Artists have responded in different ways to the smog. Simeon Lagodich portrays the sky as misty, but clean and white, while Robert Ginder presents a quite innovative interpretation: he applies gold leaf to the skies so the layer of yellow metal refers simultaneously to the intensity of the sun and to the metallic pollutants in the atmosphere that create the yellow haze and increasing opacity.

Urbanization and industrialization have been central to the development of California. The discovery of gold led to the growth of surrounding towns as miners flooded the port of San Francisco on their way to the Mother Lode Country and bought supplies in nearby Sacramento and Stockton. The newly constructed buildings, ships in the harbors, and ferries on the rivers of these northern cities were sometimes documented in topographical views. More often the early urban images emphasized the people rather than the place. While genre scenes were about the activities of the Anglo-Saxon population that Americanized the region, other cultures actively participated in the civilizing process. By the 1860s, the Chinese constituted the largest nonwhite immigrant group in the state (and would remain so until the end of the century). While some farmed or fished, others established

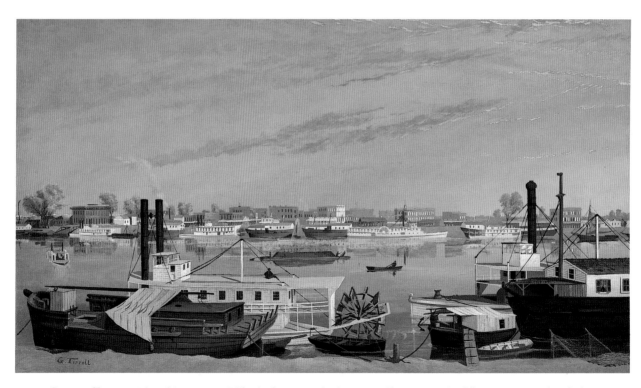

GEORGE TIRRELL. View of Sacramento, California, from across the Sacramento River, c. 1855-60, Oil on canvas, 27 x 47¾ inches

businesses in San Francisco and their unique neighborhood became the focus of many colorful street scenes by Theodore Wores. San Francisco's exotic Chinatown continued to be a popular attraction for painters and tourists well into the twentieth century.

Motorized transportation was responsible for transforming the countryside into bustling towns and metropolises. In 1869 the completion of the transcontinental railroad united Sacramento with the East Coast. Seven years later, the Central Pacific Railroad linked Los Angeles to San Francisco and by 1886 the southern city was also connected to Santa Fe by the Atchison, Topeka, and Santa Fe lines. Such junctures facilitated the migration of non-pioneer types—urban dwellers, health seekers, and tourists—and promoted rapid development of the agricultural industry by providing fast access to national markets. Yet, with the exception of William Hahn's *Sacramento Railroad Station* set in the terminus of the Central Pacific, trains were rarely the focus of late nineteenth- and early twentieth-century paintings of California. This is surprising since the railroad was frequently depicted elsewhere in American landscape painting and became one of the most potent symbols of the advances of American civilization and industrialization. The myth of California as a pastoral land was too strong to admit the inclusion of such a machine.

San Francisco was the only California city during the early

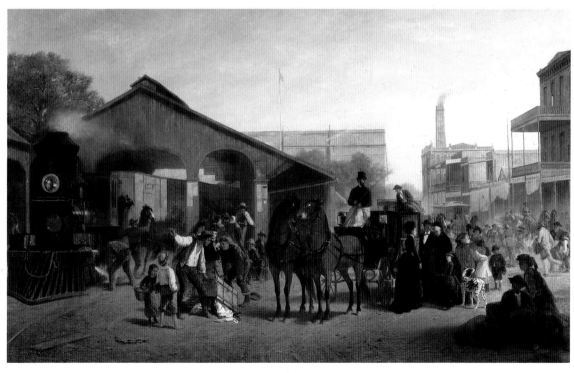

WILLIAM HAHN, Sacramento Railroad Station, 1874, Oil on canvas mounted on board, 53¾ x 87¾ inches

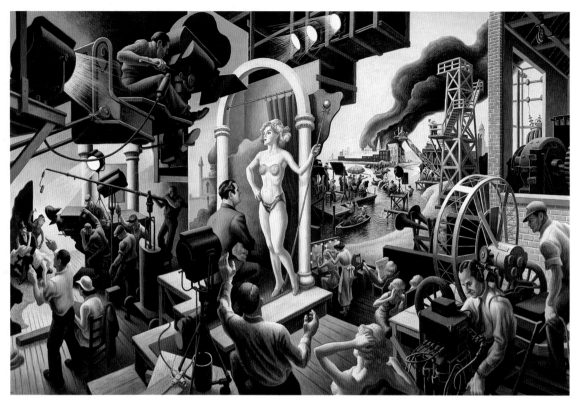

THOMAS HART BENTON, Hollywood, 1937, Oil on canvas, 53½ x 81 inches

decades of the century to compete with New York and Chicago in the erection of a condensed urban center with high-rise buildings. Such a metropolis with its huge population necessitated a form of quick and easy mass transportation. While New York and Chicago constructed elevated train lines and subway systems, San Francisco, with its unique steep terrain, encouraged a system of cable cars. Many artists, especially watercolorists active in the 1920s and 1930s, captured the picturesque views of the trolleys climbing up and down the hills with the bay and its harbor as a backdrop.

Man-made cities in the early twentieth century signified the modernity of the United States. This symbolism conflicted with the traditional myth of California as nature's wonderland. So the urban image in California Scene painting of the 1930s was at best sporadic. But World War II transformed both California and its painted depictions. Major shipping ports and naval bases were developed in San Francisco, San Pedro, and San Diego, and following the peace, the state experienced several decades of booming population, economy, and technology. The very character of much of the state changed. Cities underwent urban sprawl, while rural sections, in particular southern California, became suburbia. The popula-

tion of what once were ranch and farm lands grew so dense that new towns and cities emerged, as evidenced in Peter Alexander's recent views of areas such as Van Nuys (part of Los Angeles County in the San Fernando Valley). Based on nighttime aerial photographs that focus on the twinkling of thousands of electrical lights, Alexander's image of urban sprawl takes on a magical quality.

Los Angeles has been the heart of southern California since the 1940s. Recent paintings celebrate the massive urbanization it has experienced. Sweeping views of the metropolis inevitably include downtown skyscrapers. In contrast to scenes up until this time, the emphasis is always on man-made

expansion and development, whether it be the endless streets and freeways, or the aqueduct system (the latter was actually constructed in 1913 but seems not to have interested artists until the post-World War II era). Sometimes the vista includes a glimpse of the ocean, a reminder that nature is eternal despite the ever diminishing natural topography.

The automobile and its attendant highway culture were integral to the transformation of the state and, consequently, have become major icons of twentieth-century California art. The motorcar was invented in the 1880s, and by 1908 Henry Ford was mass-producing the Model T. In 1905, Los Angeles had 350 miles of graded streets and more horseless carriages

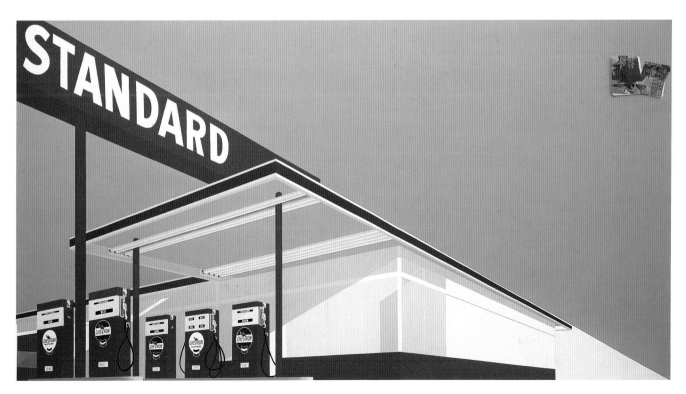

EDWARD RUSCHA, Standard Station with 10¢ Western, 1963, Oil on canvas, 65¾ x 122¼ inches

than any comparably sized city in the country. In the 1910s, the zany policemen who drove wildly through the streets of Los Angeles in the silent Keystone Cop movies associated the city with the machine. Nevertheless, motorcars did not appear often in paintings of California until the late 1920s, when they dramatically increased in number. Sometimes it was the only vehicle on an otherwise empty street in images of cities, small towns and resort communities, such as Cambria and Laguna Beach, and along backcountry roads. After all, it was the car that transported California citizenry and an increasing number of visitors from one end of the far-reaching state to the other.

Along with the thousands of miles of roads were gas stations, bus stops, and fast-food restaurants. Although construction on a system of modern highways first began during the Depression—the Arroyo Seco Parkway (now known as the Pasadena Freeway) opened in 1934—artists rarely promoted the highway culture until three decades later. Depictions of automobiles and gas stations by Berkeley artist John Haley and his followers were the exception. In the late 1960s and 1970s, Wayne Thiebaud glorified the modernity and grace of the state's highways, which were often built through treacherous terrain, and painted precipitous views of the hilly streets of San Francisco. At the same time, Ed Ruscha focused on gas stations. While the single service station symbolized California civilization for Ruscha, Stephen Hopkins perceives the state as a more cluttered, yet still essentially man-made environment. *Denny's Arco* is actually in his hometown Santa Rosa, but as he explains, "It could be any of a lot of places, especially in California where the elements of so-called civilization such as gas stations, motels, signs, and light poles are scattered amidst a naturalistic setting."

Los Angeles artists have developed the automobile and highway imagery to its fullest. Beginning in the 1960s, the Beach Boys idolized hotrods and cruising in hit car songs like "I Get Around." At the same time local Photorealists also worshipped the automobile, presenting it as an object on display. Frank Romero incorporates humor, derived partly from his vivid colors and naive draftsmanship, to suggest that playfulness is one alternative to the frustrations that pervade contemporary California life. He does not depict automobiles as streamlined machines speeding along streets, but as rambling vehicles; in his 1986 view of Angelino Heights, near downtown Los Angeles, the inclusion of the "Big Red" trolley from a by-gone era demonstrates his anachronistic denial of reality. Other recent contemporary perspectives are less idealistic. As traffic on the highways exploded, other artists began to depict the situation in increasingly surreal terms: the roads become long ribbons swirling around buildings and jammed with tiny machines that go nowhere. James Doolin portrays the entire horrendous experience in *Highway Patrol, #1* by placing the viewer behind the steering wheel looking through the windshield at the streams of traffic, all illuminated by the glare of a brilliantly gold, polluted sky—a sad and ironic twist to the fate of the mythical golden land.

The paintings of California in the past century-and-a-half clearly demonstrate that the place is truly "the stuff that dreams are made of." Despite the serious problems faced by the state today, the myth of a better life will prevail. What form the myth will take is not known, but the nature of the artistic response is certain. Painters will continue to comment passionately about life in California, extolling its popular culture as well as the soul of its land and people.

Ilene Susan Fort
August 1992 / 1997

PURSUING MY LONELY WAY DOWN THE VALLEY,
I turned again and again to gaze on the glorious picture, throwing up my arms to enclose it
as in a frame. After long ages of growth in the darkness beneath the glaciers, through sunshine
and storms, it seemed now to be ready and waiting for the elected artist, like yellow wheat
for the reaper; and I could not help wishing that I were that artist. I had to be content,
however, to take it into my soul.

JOHN MUIR, *A Near View of the High Sierra*, 1880

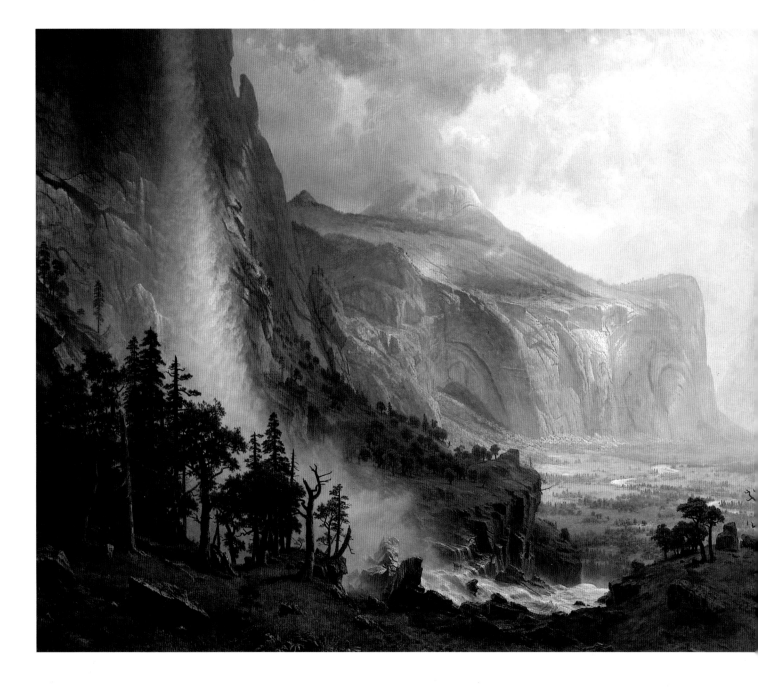

NEVER HAD I BEHELD A NOBLER ATLAS OF MOUNTAINS.
A thousand pictures composed that one mountain countenance, glowing with the Holy Spirit of
Light! I crept along on the rugged edge of the wall until I found a place where I could sit down
to absorb the glorious landscape in safety. The Tuolumne River shimmered and spangled below,
showing two or three miles of its length, curving past sheer precipices and meandering through
groves and small oval meadows. Its voice I distinctly heard, giving no tidings of heavy falls;
but cascade tones, and those of foaming rapids, were in it, fused into harmony as smooth
as the wind-music of the pines. . . .

JOHN MUIR, *Explorations in the Great Tuolomne Cañon*, 1873

ALBERT BIERSTADT, Domes of the Yosemite, 1867, Oil on canvas, 116 x 180 inches 27

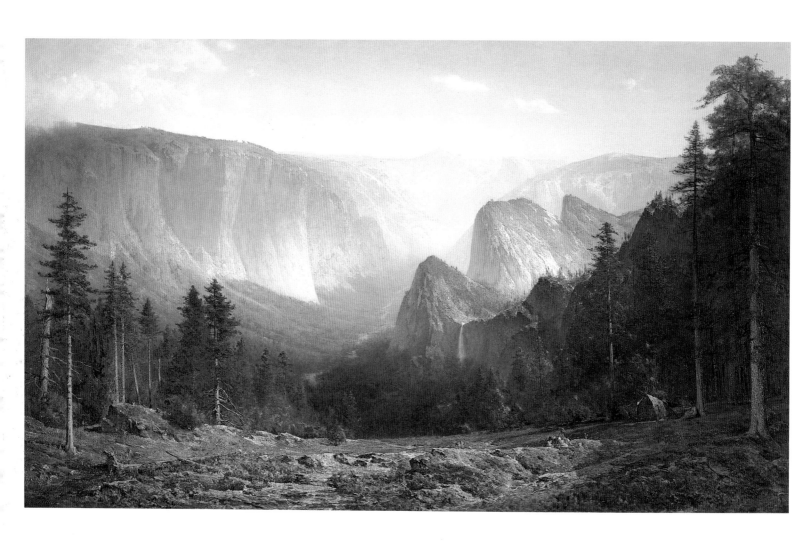

THOMAS HILL, Great Canyon of the Sierra, Yosemite, 1871, Oil on canvas, 72 x 120 inches (*detail opposite*)

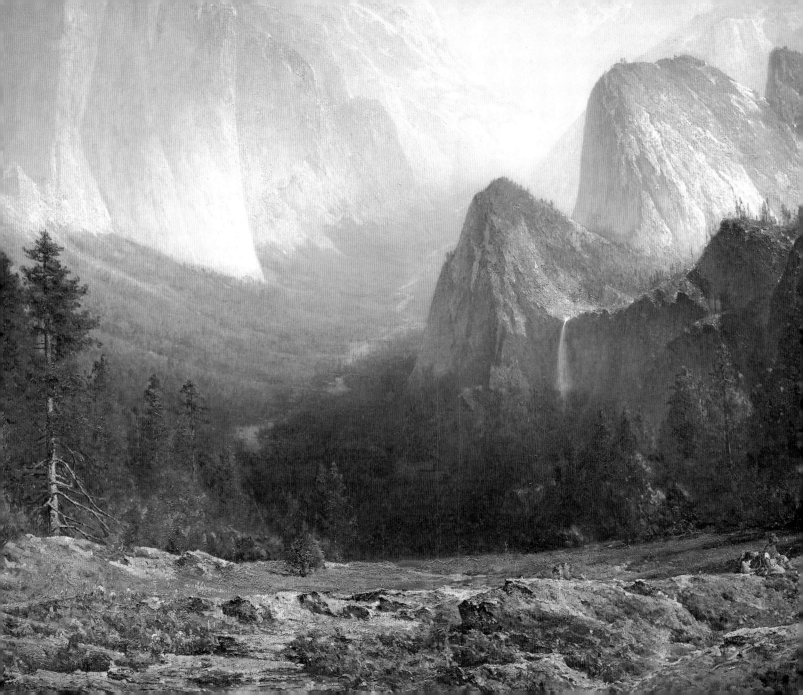

THESE ROCKS ARE FULL OF TEXTS AND TEACHING
—these cliffs are tables of stone, graven with laws and commandments.
I read everywhere mysterious cyphers and hieroglyphics;
every changing season offers to me a new palimpsest.

CHARLES WARREN STODDARD, *In Yosemite Shadows*, 1869

FREDERICK BUTMAN, Yosemite Falls, 1859, Oil on canvas, 36 x 45 ¼ inches

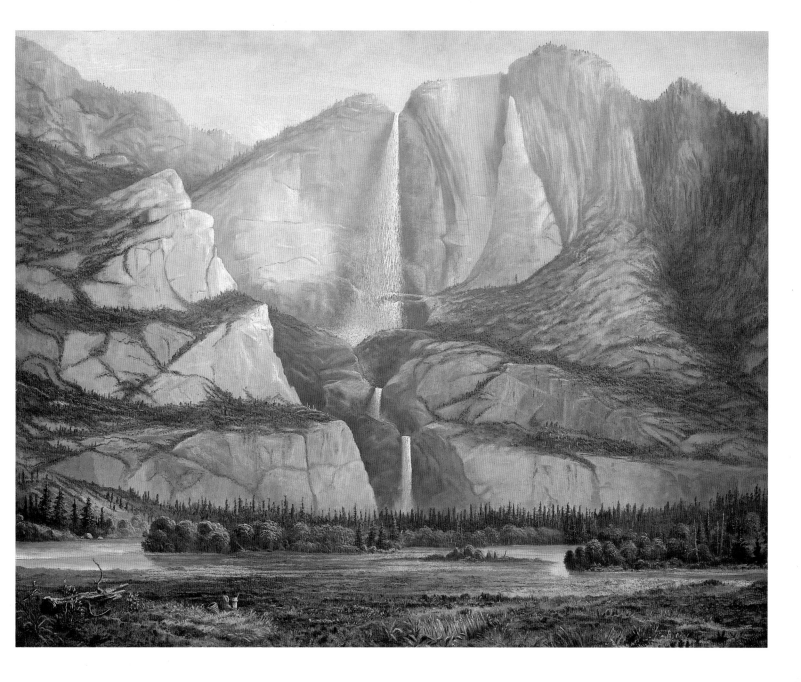

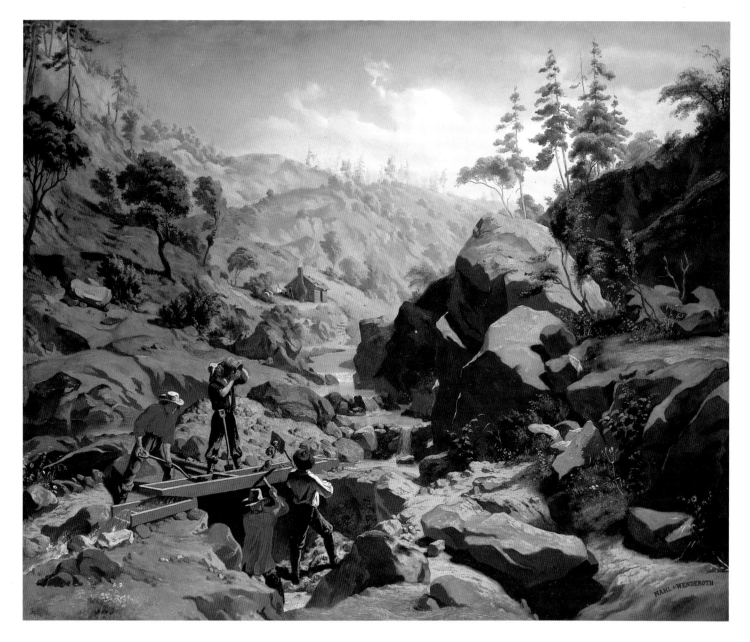

CHARLES NAHL with FREDERICK A. WENDEROTH, Miners in the Sierras, 1851-52, Oil on canvas, 54¼ x 67 inches

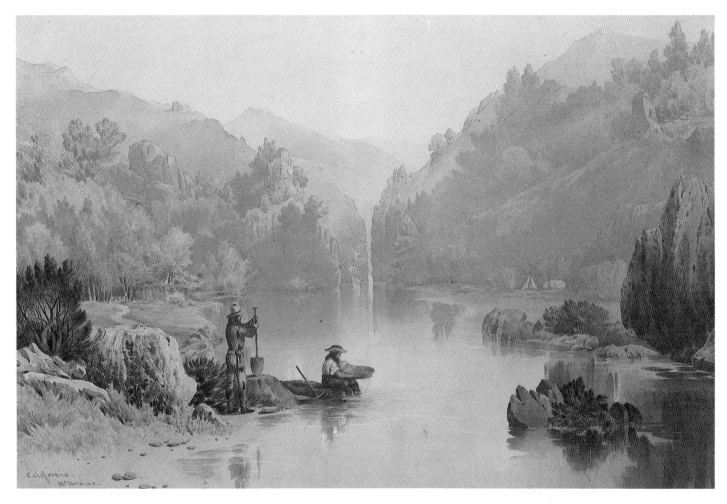

I soon shall be in Frisco, O California
 And then I'll look around; That's the land for me:
And when I see the gold lumps there, I'm bound for San Francisco,
 I'll pick them off the ground. With my washbowl on my knee.

Song from the Gold Rush era

WILLIAM MCILVAINE, Panning Gold, California, n.d., Watercolor over pencil on paper, 18⅝ x 27½ inches

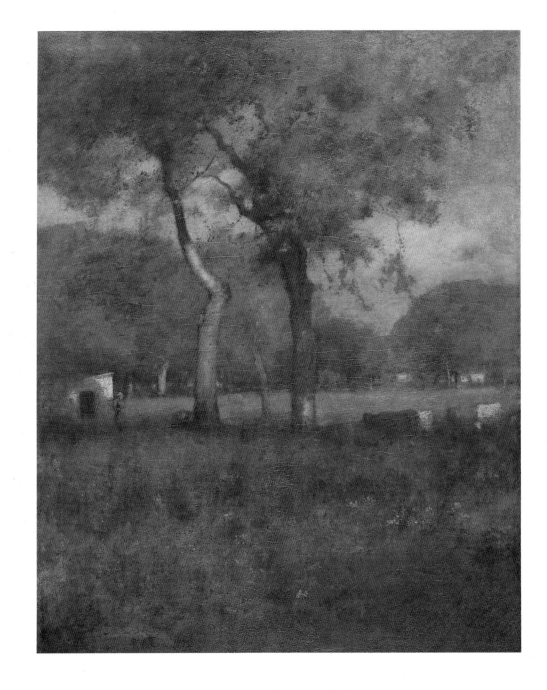

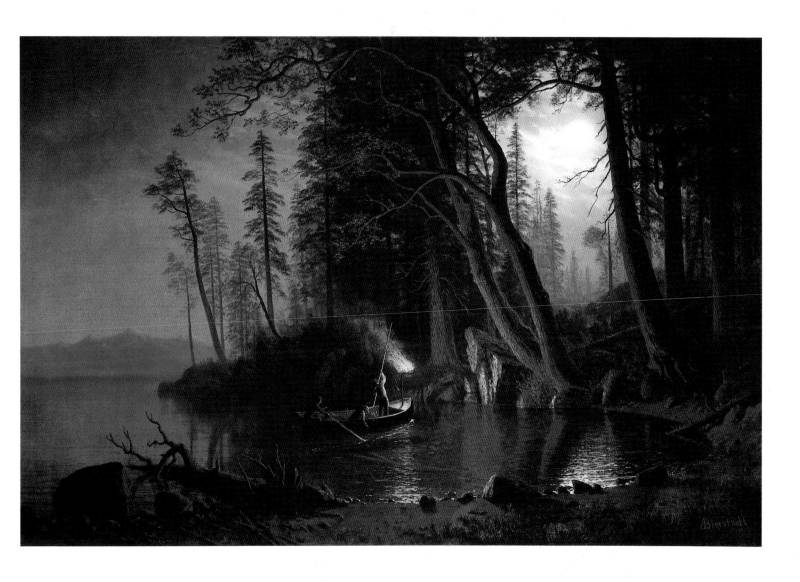

ALBERT BIERSTADT, Lake Tahoe, Spearing Fish by Torchlight, c. 1875, Oil on canvas, 31½ x 49 inches

GEORGE INNESS, California, 1894, Oil on canvas, 60 x 48 inches (*opposite*)

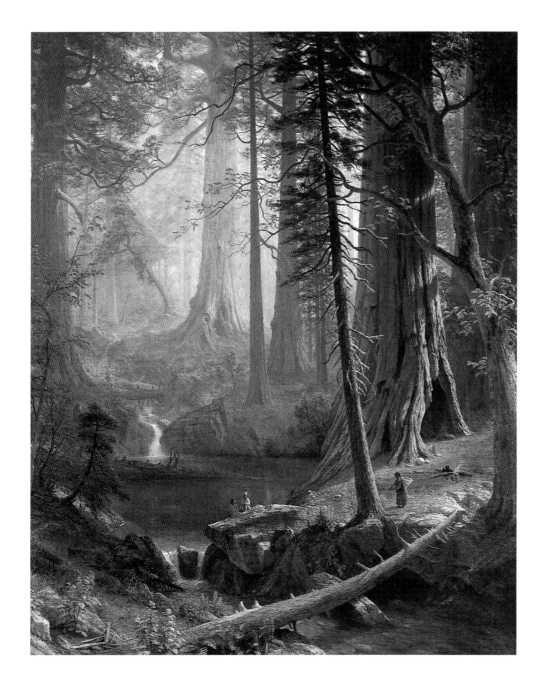

ALBERT BIERSTADT
Giant Redwood Trees of California, 1874
Oil on canvas, 52½ x 43 inches

MURMURING out of its myriad leaves,
Down from its lofty top rising two hundred feet high,
Out of its stalwart trunk and limbs, out of its foot-thick bark,
That chant of the seasons and time, chant not of the past
 only but the future.

WALT WHITMAN, *Song of the Redwood-Tree*, 1873

JULIAN RIX, Landscape, (Twilight Scene with Stream and Redwood Trees), n.d.
Oil on canvas, 83 ½ x 46 ½ inches

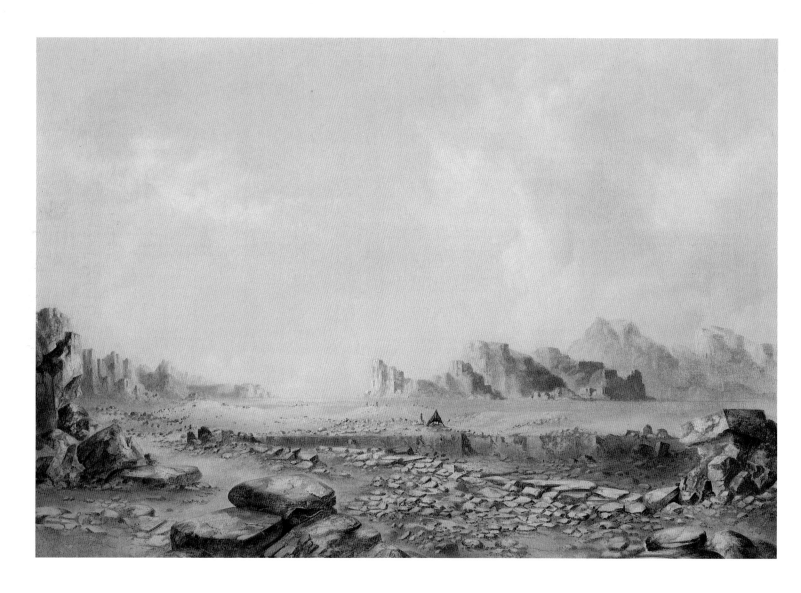

Lt. George D. Brewerton, Jornada del Muerto, 1853, Oil on canvas, 30 x 44 inches

Fernand Lungren, Death Valley, Dante's View, n.d., Oil on canvas, 26 x 60 inches (*opposite*)

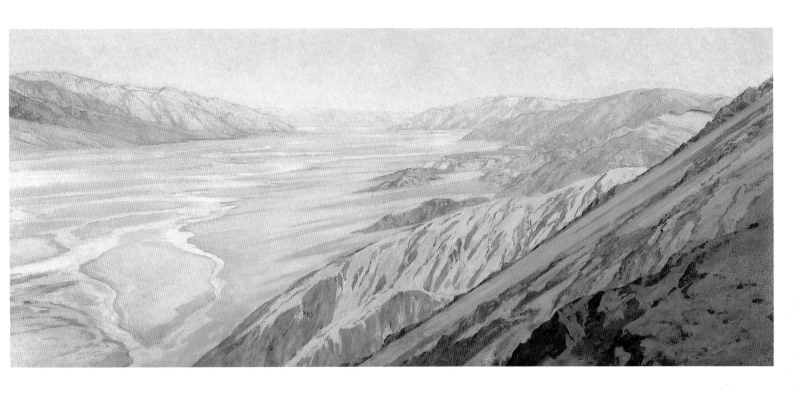

THE MORE ONE STAYS HERE, THE MORE ONE IS STRUCK
by the arid character of the earth's face. There is nothing here but rock and stone and gravel.
Given such an aspect of the earth, we should expect the lizards, which swarmed thick on every
side, and the rattlesnakes, which grew here, as they told us, to unusual bigness...

ROBERT LOUIS STEVENSON, 1883

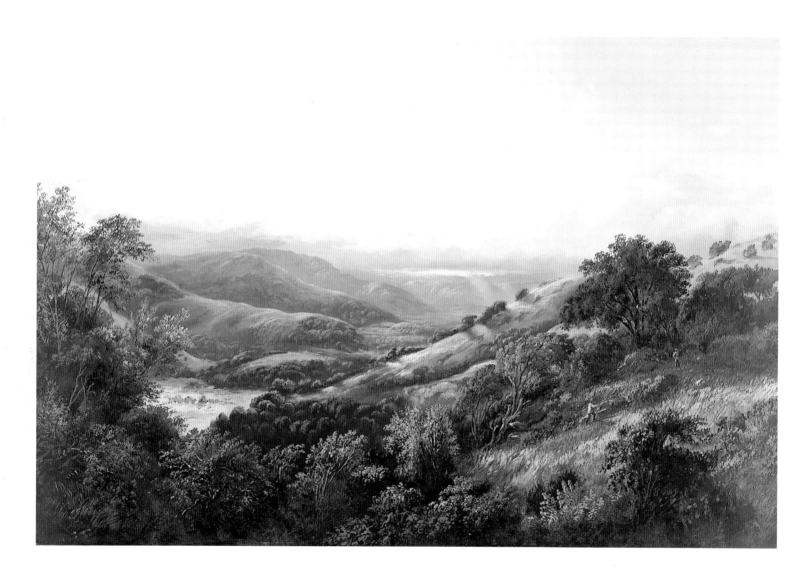

WILLIAM KEITH, San Anselmo Valley Near San Rafael, 1869, Oil on canvas, 24 x 36¼ inches

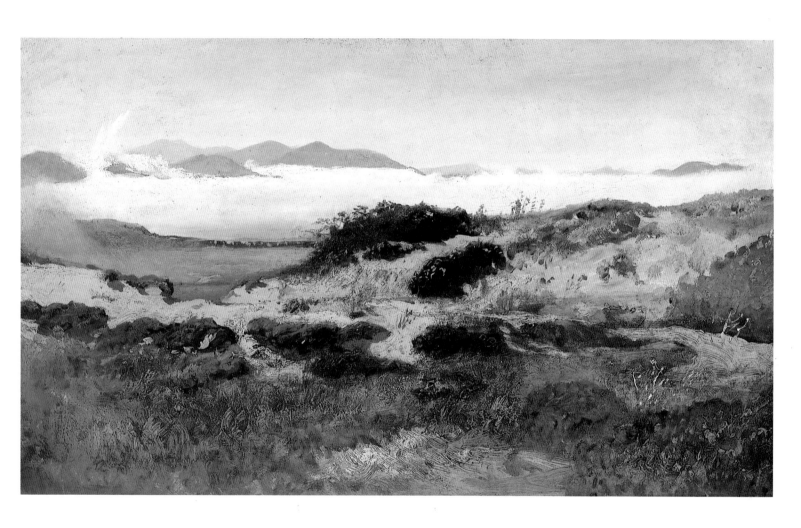

WILLIAM KEITH, Sand Dunes and Fog, San Francisco, early 1880s, Oil on canvas mounted on composition board, 15¼ x 25¼ inches

W HEN I LOOKED ACROSS THE BAY TO THE EASTWARD,
and beheld a beautiful town on the fertile, wooded shores of the Contra Costa, and steamers,
large and small, the ferryboats to the Contra Costa, and capacious freighters and passenger
carriers to all parts of the great bay and its tributaries, with lines of their smoke in the horizon—
when I saw all these things, and reflected on what I once was and saw here, and what now
surrounded me, I could scarcely keep my hold on reality at all, or the genuineness
of anything, and seemed to myself like one who had moved in "worlds not realized."

RICHARD HENRY DANA, JR., *Two Years Before The Mast*, 1840

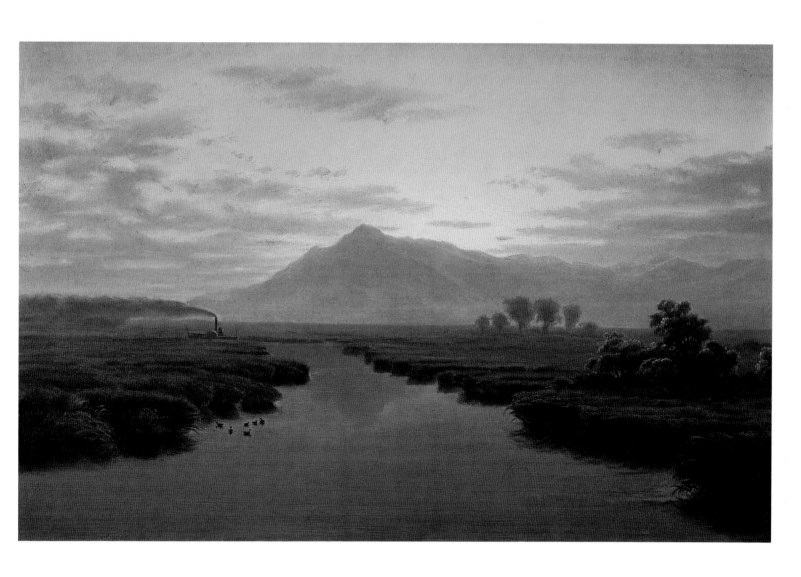

WILLIAM MARPLE, Mount Tamalpais from Napa Slough, 1869, Oil on canvas, 20 x 32 inches

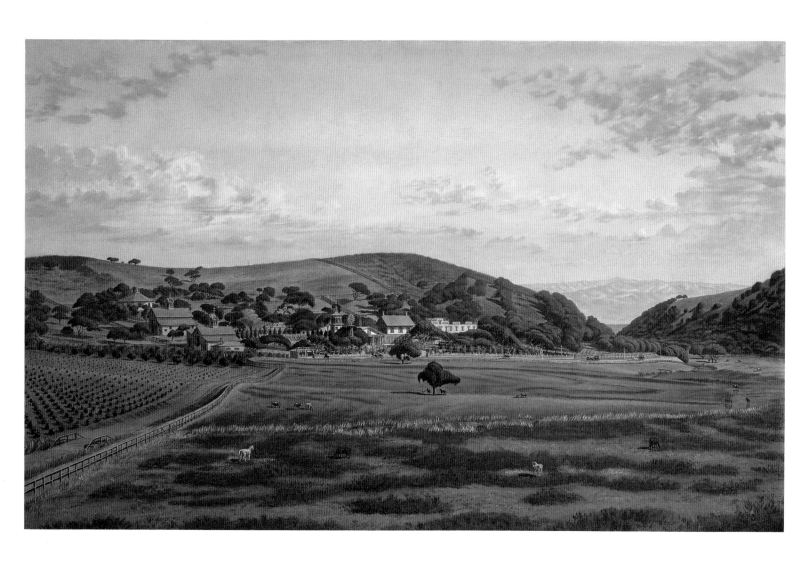

44 JOSEPH LEE. Ralston Hall and its Grounds, San Mateo County, c. 1865-66, Oil on canvas, 30 x 47⅞ inches

THE flashing and golden pageant of California,

The sudden and gorgeous drama, the sunny and ample lands,

The long and varied stretch from Puget Sound to Colorado south,

Lands bathed in sweeter, rarer, healthier air, valleys and mountain cliffs,

The fields of Nature long prepared and fallow, the silent, cyclic chemistry,

The slow and steady ages plodding, the unoccupied surface ripening, the rich ores forming beneath;

At last the New arriving, assuming, taking possession,

A swarming and busy race settling and organizing everywhere,

Ships coming in from the whole round world, and going out to the whole world,

To India and China and Australia and the thousand island paradises of the Pacific,

Populous cities, the latest inventions, the steamers on the rivers, the railroads, with many a
 thrifty farm, with machinery,

And wood and wheat and the grape, and diggings of yellow gold.

WALT WHITMAN, *Song of The Redwood-Tree, 1873*

THE WHEAT, NOW CLOSE TO ITS MATURITY,
had turned from pale yellow to golden yellow, and from that
to brown. Like a gigantic carpet, it spread itself over all the
land. There was nothing else to be seen but the limitless sea
of wheat as far as the eye could reach, dry, rustling, crisp and
harsh in the rare breaths of hot wind out of the southeast.

FRANK NORRIS, *The Octopus: A Story of California*, 1901

WILLIAM HAHN, Harvest Time, 1875
Oil on canvas, 36 x 70 inches

47

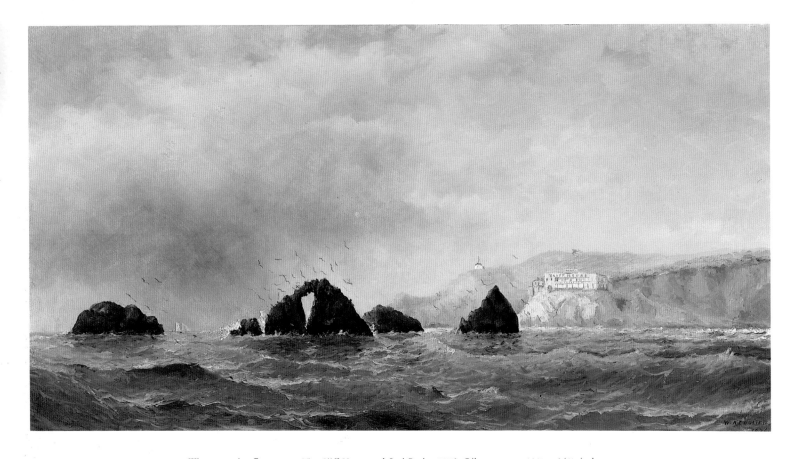

WILLIAM A. COULTER, The Cliff House and Seal Rocks, 1876, Oil on canvas, 18¼ x 34¼ inches

AT the equinox when the earth was veiled in a late
 rain, wreathed with wet poppies, waiting spring,
The ocean swelled for a far storm and beat its
 boundary, the ground-swell shook the beds of
 granite.

I gazing at the boundaries of granite and spray, the
 established sea-marks, felt behind me
Mountain and plain, the immense breadth of the
 continent, before me the mass and doubled
 stretch of water.

I said: You yoke the Aleutian seal-rocks with the lava
 and coral sowings that flower the south,
Over your flood the life that sought the sunrise faces
 ours that has followed the evening star.

ROBINSON JEFFERS, *Continent's End*, 1924

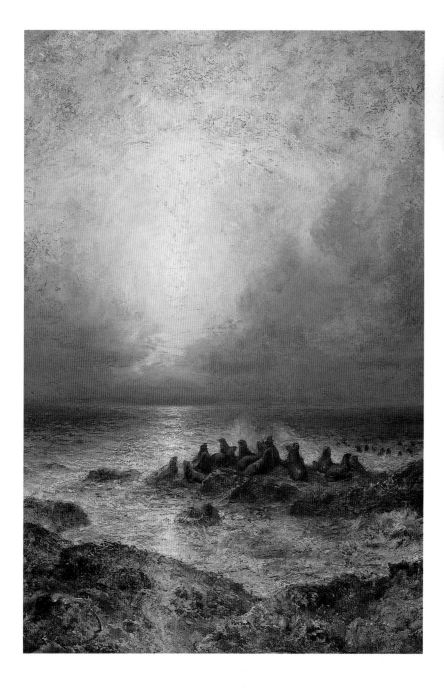

RALPH ALBERT BLAKELOCK, Seal Rocks, c. 1880
Oil on canvas, 42 x 31 inches

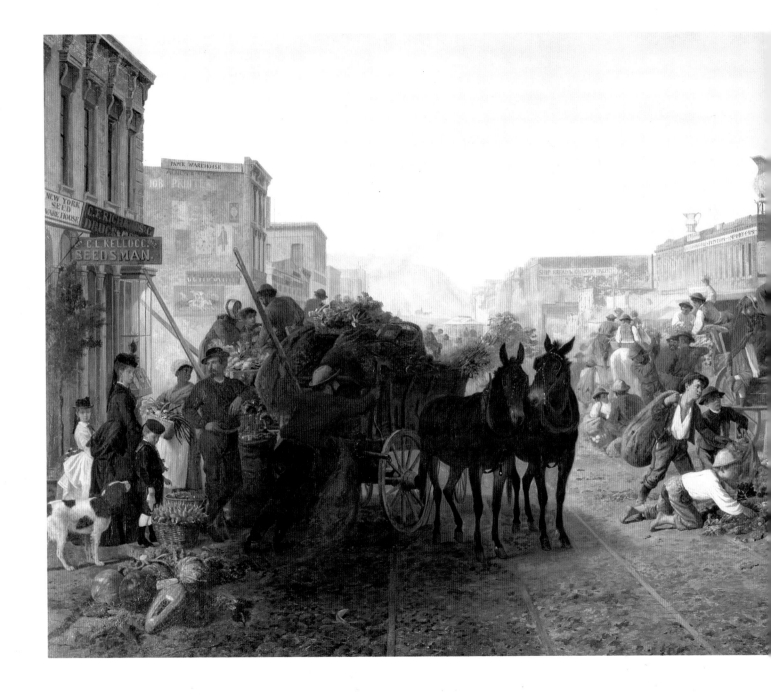

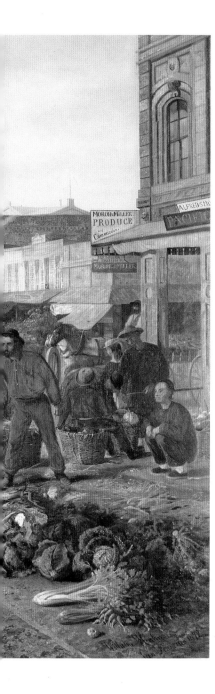

THIS STRAGGLING TOWN SHALL BE A VAST METROPOLIS:
this sparsely populated land shall become a crowded hive of busy men: your waste places shall
blossom like the rose and your deserted hills and valleys shall yield bread and wine for
unnumbered thousands: railroads shall be spread hither and thither and carry the invigorating
blood of commerce to regions that are languishing now: mills and workshops, yea, and *factories*
shall spring up everywhere, the mines that have neither name nor place today
shall dazzle the world with their affluence. The time is drawing on apace when the
clouds shall pass away from your firmament, and a splendid prosperity shall descend like
a glory upon the whole land!

MARK TWAIN, *Farewell*, 1866

WILLIAM HAHN, Market Scene, Sansome Street, San Francisco, 1872, Oil on canvas, 60 x 96 inches 51

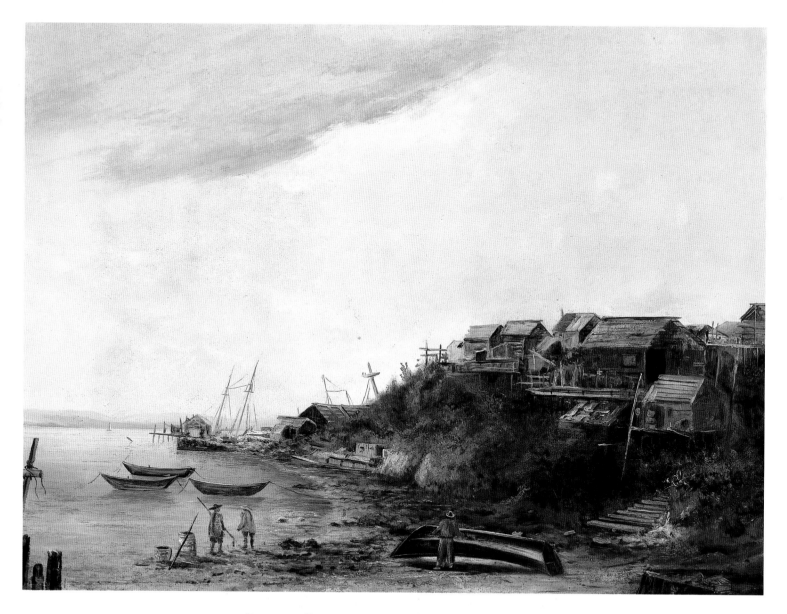

FREDERICK BUTMAN, Chinese Fishing Village, n.d., size unknown

THEODORE WORES, New Year's Day in San Francisco's Chinatown, 1881, Oil on canvas, 29 x 22 inches (*opposite*)

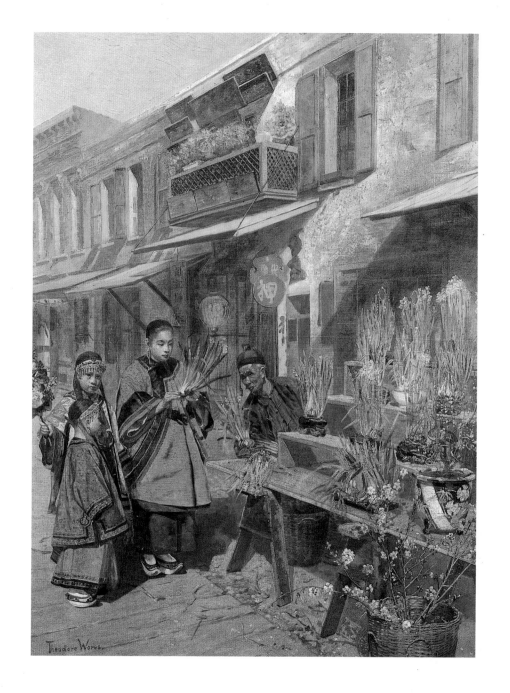

Theodore Wores.

From the West Window of My Room

I look out on the mission buildings. The sun rests on them from sunrise to sunset, and they seem to me to say more than any human voice on record can convey.

Helen Hunt Jackson, 1882

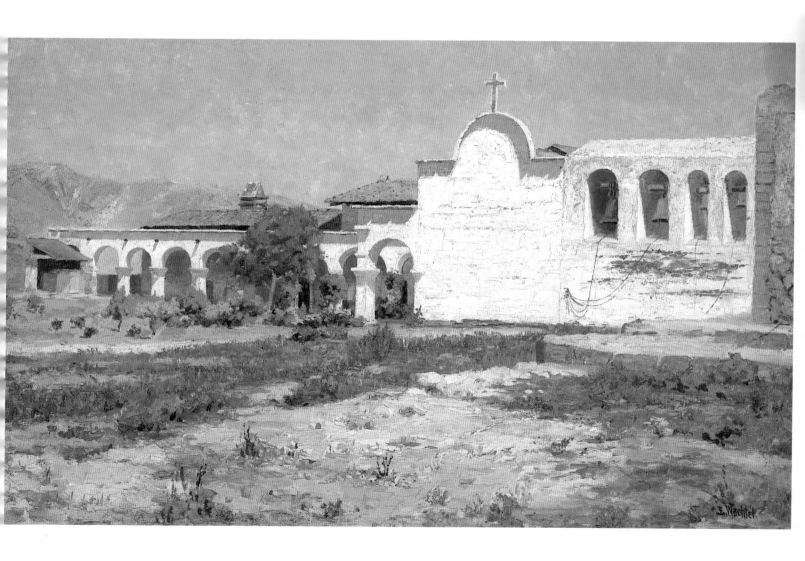

ELMER WACHTEL, Capistrano Mission, c. 1900, Oil on canvas, 15 x 25½ inches

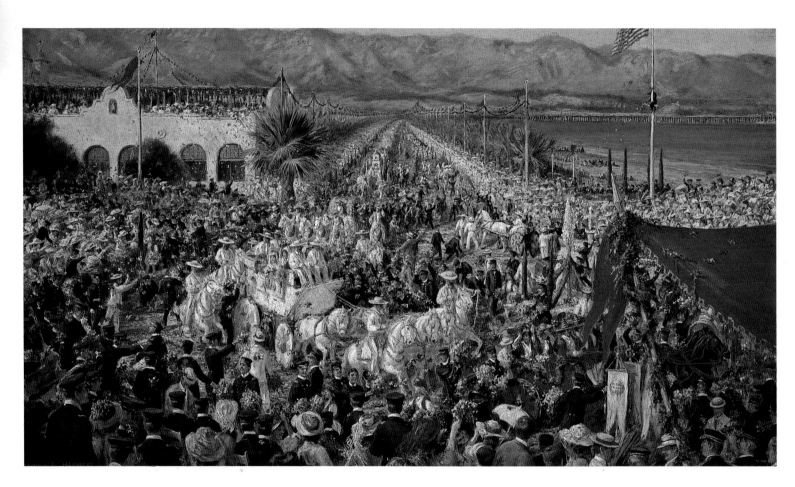

ALEXANDER HARMER, Battle of the Flowers, Fleet Festival, 1908, Oil on canvas, 20 x 36 inches

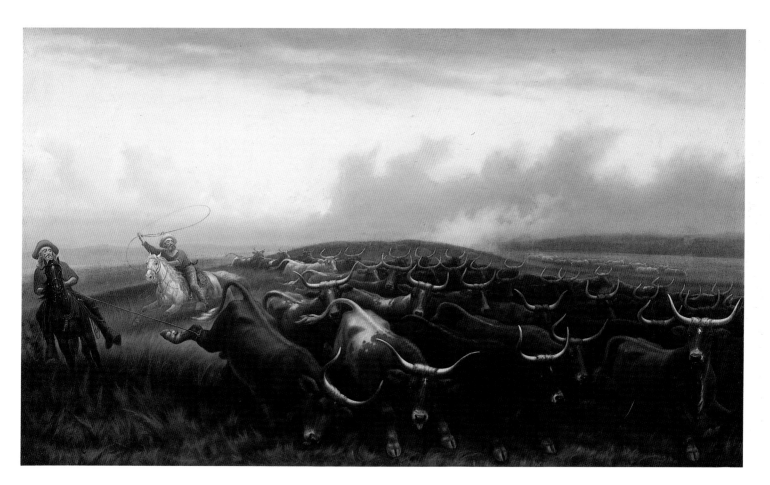

JAMES WALKER, Cattle Drive No. 1, c. 1877, Oil on canvas, 30¼ x 50 inches

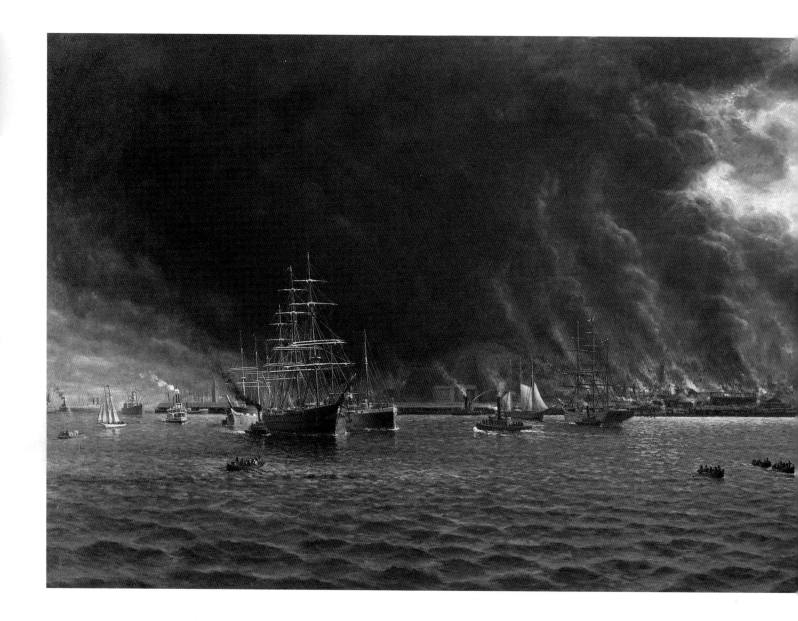

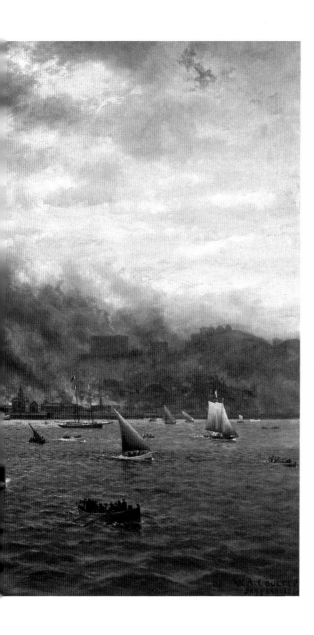

NOT IN HISTORY HAS A MODERN IMPERIAL CITY
been so completely destroyed. San Francisco is gone....Within an hour after
the earthquake shock the smoke of San Francisco's burning was a lurid
tower visible a hundred miles away. And for three days and nights, this lurid
tower swayed in the sky, reddening the sun, darkening the day, and filling
the land with smoke.

JACK LONDON, *The Fire*, 1906

WILLIAM A. COULTER, San Francisco Fire, 1906, Oil on canvas, 60 x 120 inches

59

OFTEN, WHEN FOLLOWING THE TRAIL
which meanders over the hills, I pull myself up in an effort to encompass the glory and the
grandeur which envelops the whole horizon. Often, when the clouds pile up in the north
and the sea is churned with white caps, I say to myself: "This is the California that men
dreamed of years ago, this is the Pacific that Balboa looked out on from the Peak of Darien,
this is the face of the earth as the Creator intended it to look."

HENRY MILLER, *Big Sur and the Oranges of Hieronymus Bosch*, 1957

CHILDE HASSAM, The Silver Veil and the Golden Gate, 1914, Oil on canvas, 29⅝ x 31⅝ inches

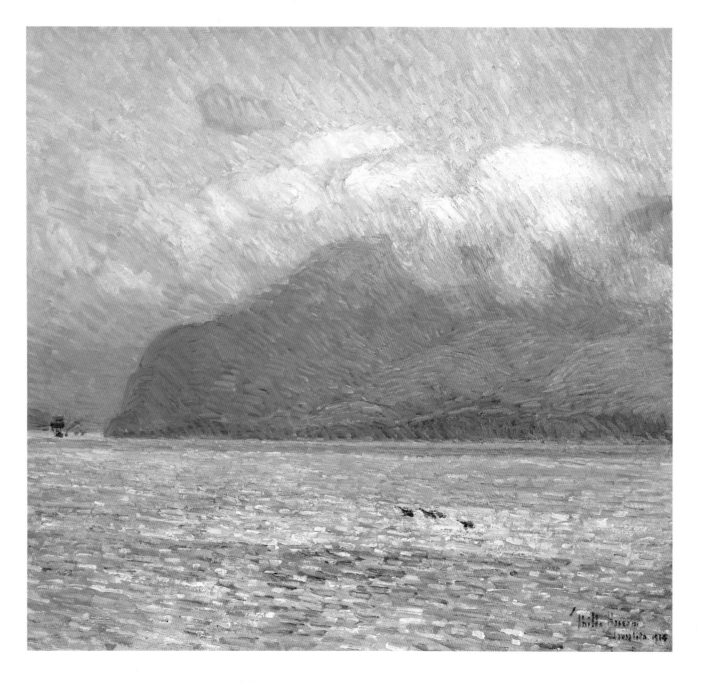

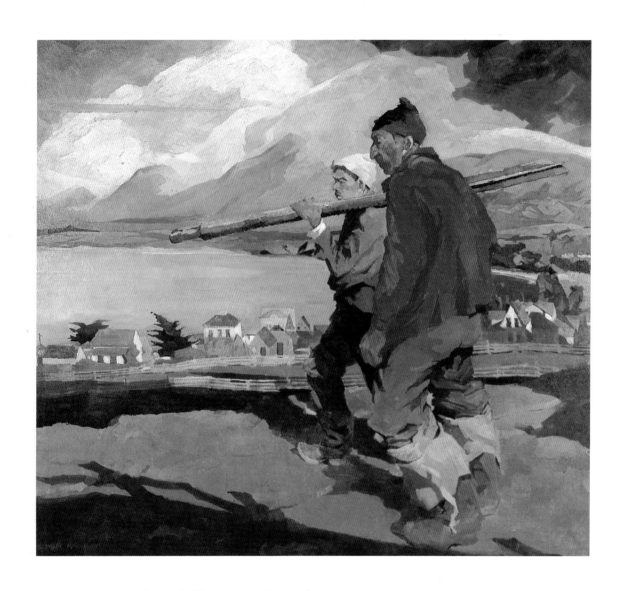

ARMIN C. HANSEN, Men of the Sea, n.d., Oil on canvas, 51⅜ x 57 inches

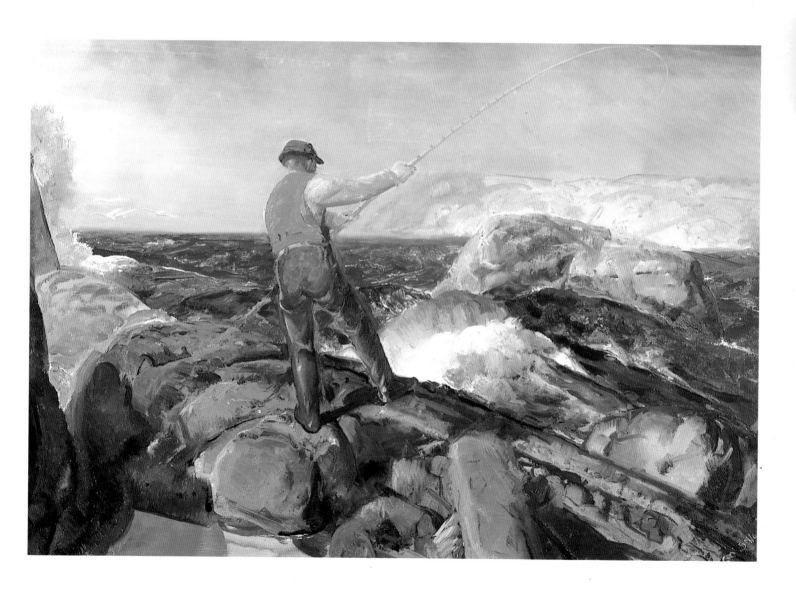

GEORGE BELLOWS, The Fisherman, 1917, Oil on canvas, 30 x 44 inches

BIG SUR HAS A CLIMATE OF ITS OWN
and a character all its own. It is a region where extremes meet, a region where one is always
conscious of weather, of space, of grandeur, and of eloquent silence.

HENRY MILLER, *Big Sur and the Oranges of Hieronymous Bosch,* 1957

MILLARD SHEETS, Old Mill, Big Sur, 1933, Watercolor on paper, 22 x 30 inches

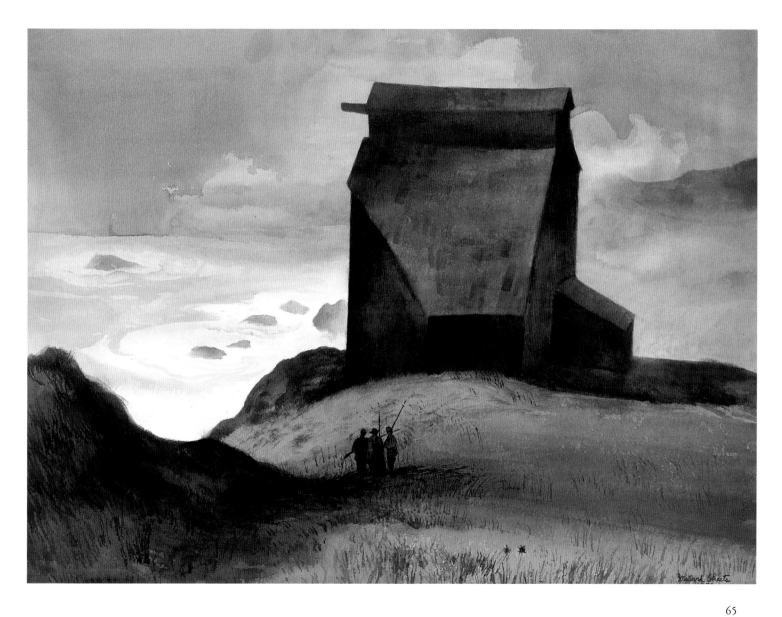

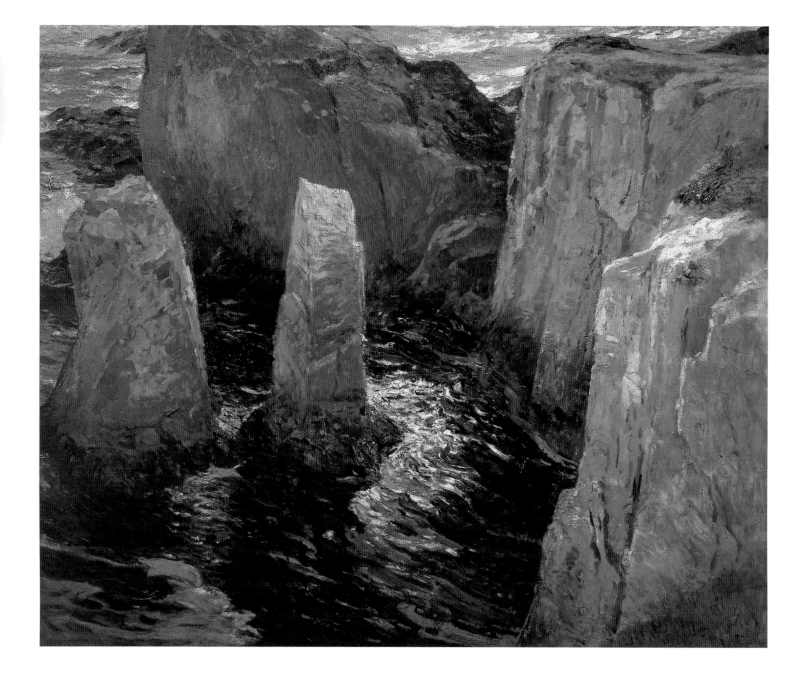

BIG ELBOWS OF ROCK RISING EVERYWHERE,
sea caves within them, seas plollocking all around inside them crashing out foams, the boom and
pound on the sand, the sand dipping quick (no Malibu Beach here) — Yet you turn and see the
pleasant woods winding upcreek like a picture in Vermont — But you look up into the sky, bend
way back, my God you're standing directly under that aerial bridge with its thin white line
running from rock to rock and witless cars racing across it like dreams! From rock to rock!
All the way down the raging coast! So that when later I heard people say "Oh Big Sur must be
beautiful!" I gulp to wonder why it has the reputation of being beautiful above and beyond its
fearfulness, its Blakean groaning roughrock Creation throes, those vistas when you drive the coast
highway on a sunny day opening up the eye for miles of horrible washing sawing.

JACK KEROUAC, *Big Sur,* 1960

"'**W**HAT'S on the other side?' he asked his father once.

"'More mountains, I guess. Why?'

"'And on the other side of them?'

"'More mountains. Why?'

"'More mountains on and on?'

"'Well, no. At last you come to the ocean.'

"'But what's in the mountains?'

"'Just cliffs and brush and rocks and dryness.'

"'Were you ever there?'

"'No.'

"'Has anybody ever been there?'

"'A few people, I guess. It's dangerous, with cliffs and things.
 Why, I've read there's more unexplored country in the mountains
 of Monterey County than any place in the United States.'
 His father seemed proud that this should be so.

"'And at last the ocean?'

"'At last the ocean.'

"'But,' the boy insisted, 'but in between? No one knows?'

"'Oh, a few people do, I guess. But there's nothing there to get.
 And not much water. Just rocks and cliffs and greasewood. Why?'

"'It would be good to go.'

"'What for? There's nothing there.'"

JOHN STEINBECK, *The Red Pony*, 1933

CHARLES REIFFEL, In the San Felipe Valley, Oil on canvas, 33½ x 36½ inches

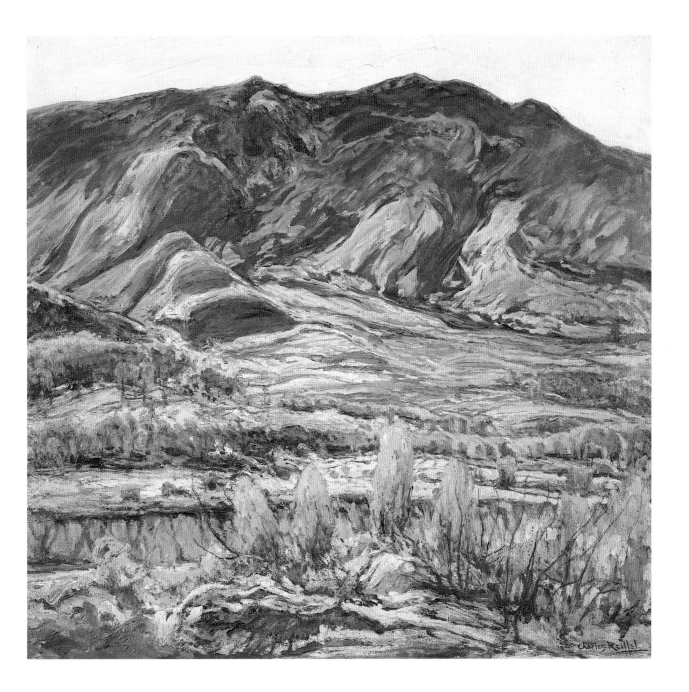

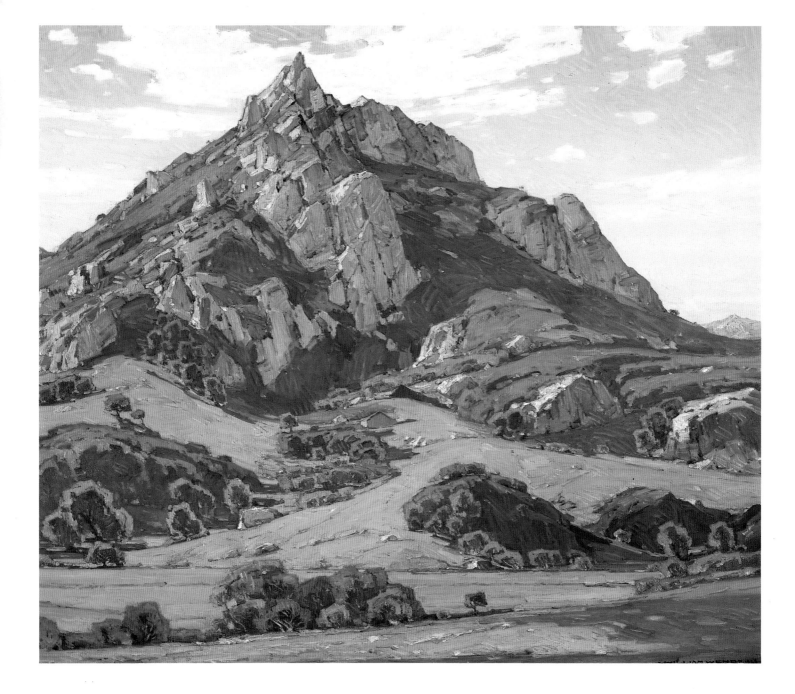

A story about Indians,
the tribe that claimed Mt. Shasta...

Five lawyers said, "It's ridiculous!
What possible use can they have for the mountain?"

The interpreter said, "Your Honor,
they say that their gods live there."

LOUIS SIMPSON, *The Climate Of Paradise*, 1971

WILLIAM WENDT, Where Nature's God Hath Wrought, 1925, Oil on canvas, 50 ½ x 60 inches

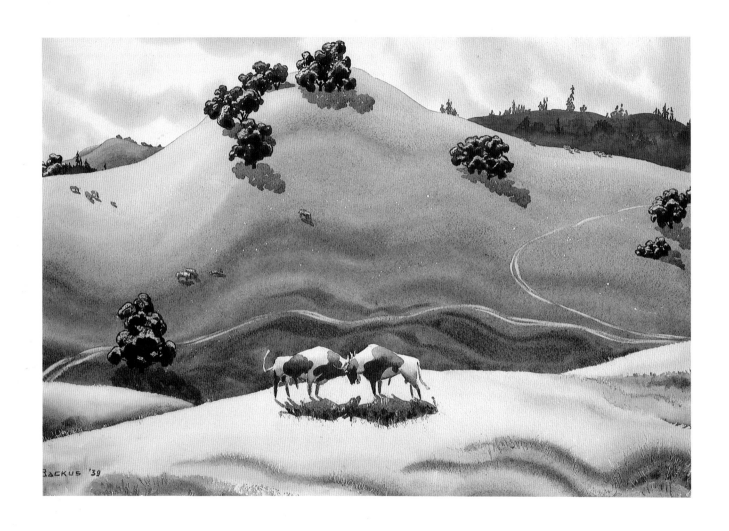

STANDISH BACKUS, JR., Untitled, Two Bulls, 1939, Watercolor, 15 x 21 inches

PHIL PARADISE, Ranch Near San Luis Obispo, Evening Light, c. 1935, Oil on canvas, 28 x 34 inches (*opposite*)

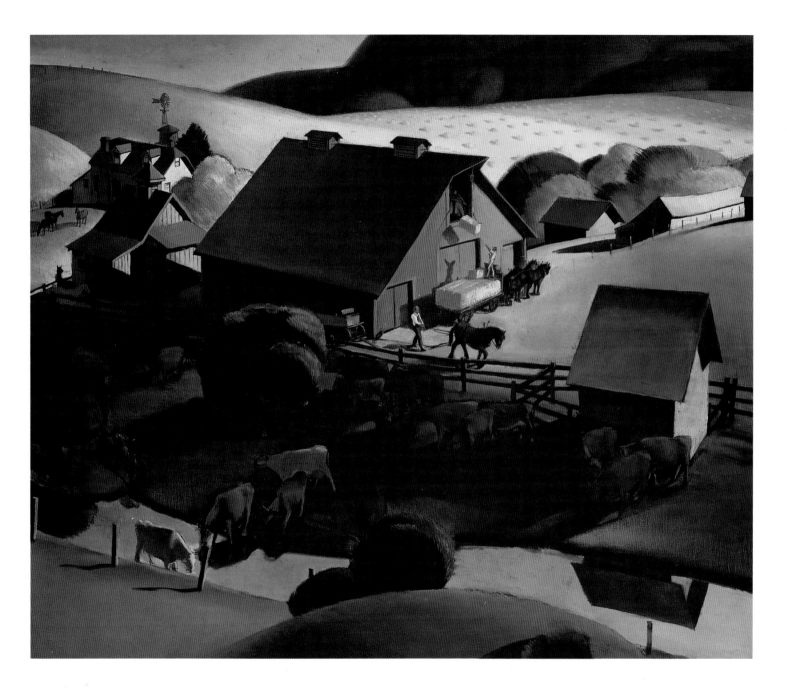

As far as the eye can reach it extends,
a heaving, swelling sea of green as regular and continuous as that produced by the heaths of
Scotland. The sculpture of the landscape is as striking in its main lines as in its lavish
richness of detail....The whole landscape showed design, like man's noblest sculptures. How
wonderful the power of its beauty! Gazing awestricken, I might have left everything for it.

JOHN MUIR, *My First Summer in the Sierra*, 1867

TOM CRAIG, Into the Sun, c. 1933, Oil on canvas, 30 x 35 inches

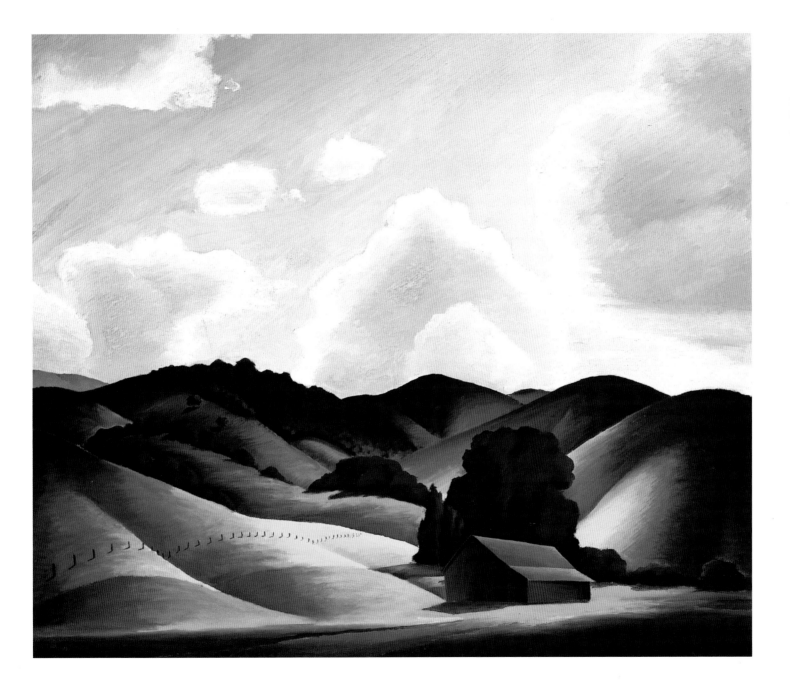

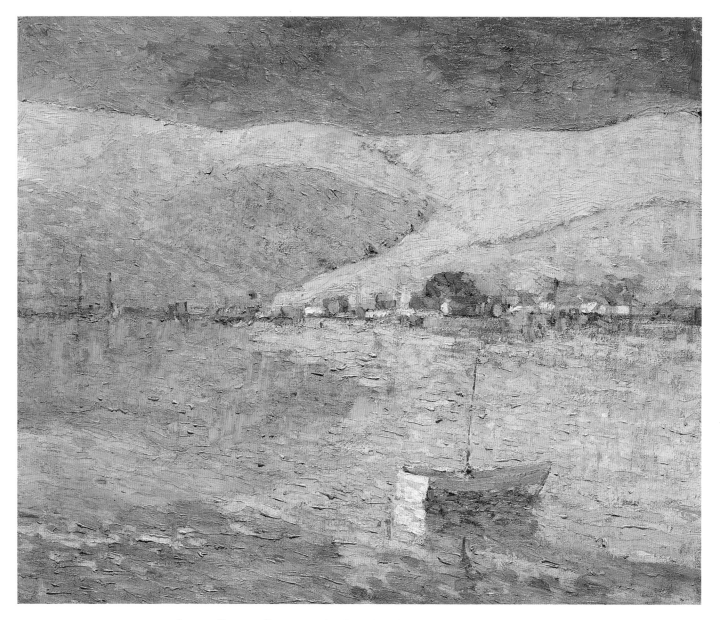

SELDEN CONNOR GILE, Boat and Yellow Hills, n.d., Oil on canvas, 30½ x 36 inches

SELDEN CONNOR GILE, The Soil, 1927, Oil on canvas, 30 x 36 inches

GRANVILLE REDMOND, *California Poppy Field*, c. 1926, Oil on canvas, 40¼ x 60¼ inches

THE SPRING FLOWERS IN A WET YEAR WERE UNBELIEVABLE.
The whole valley floor, and the foothills too, would be carpeted with lupins and poppies.
Once a woman told me that colored flowers would seem more bright if you added a few white
flowers to give the colors definition. Every petal of blue lupin is edged with white, so that a field
of lupins is more blue than you can imagine. And mixed with these were splashes of California
poppies. These too are of a burning color—not orange, not gold, but if pure gold were liquid
and could raise a cream, that golden cream might be like the color of the poppies.

JOHN STEINBECK, *East of Eden*, 1952

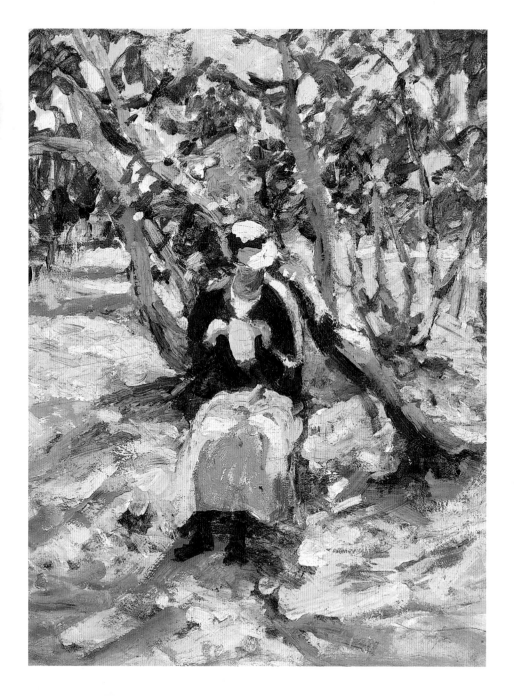

THERE SEEMS TO EXIST IN THIS COUNTRY
a something which cheats the senses. Whether it
be in the air, the sunshine, in the ocean
breeze....There is a variety in the evenness
of the weather, and a strange evenness in this
variety, which throws an unreality around life....
All alike walk and work in a dream.
For something beguiles, deludes, plays falsely
with the senses....In Cincinnati I would have
sensed the going by of nine honest, substantial
hours; but here I do not.

CAREY MCWILLIAMS
Southern California Country: An Island on the Land, 1946

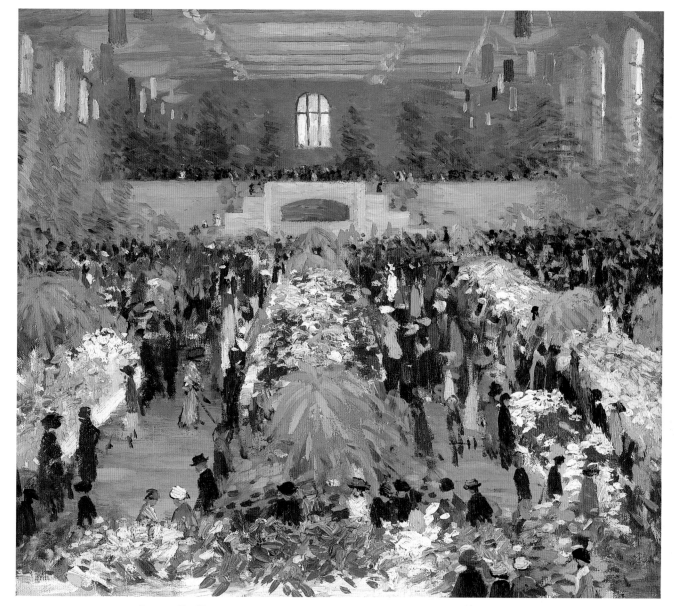

ALFRED R. MITCHELL, Flower Show in Balboa Park, c. 1925, Oil on canvas, 18 x 20 inches

AUGUST GAY, Woman in the Garden, c. 1923, Oil on canvas, 20 x 16 inches (*opposite*)

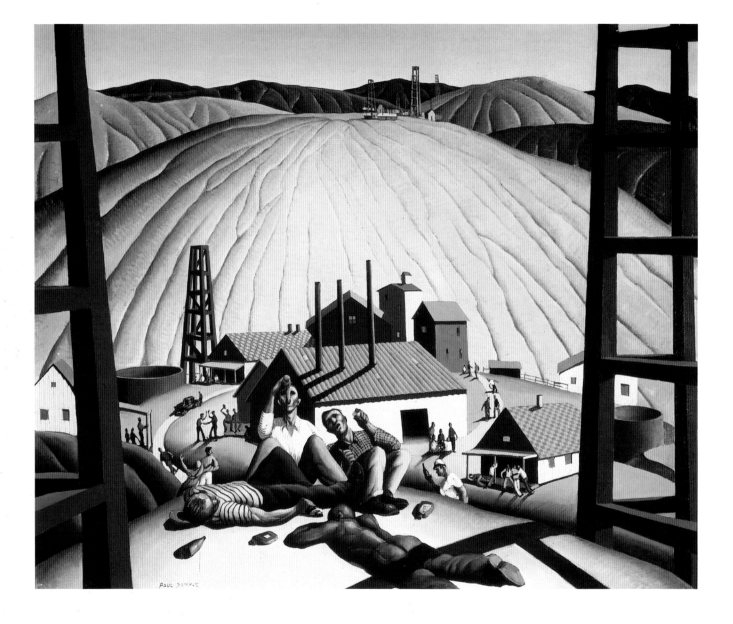

PAUL SAMPLE, Celebration, 1933, Oil on canvas, 40 x 48 inches

MILLARD SHEETS, Tenement Flats (Family Flats), 1934, Oil on canvas, 40¼ x 50¼ inches (*opposite*)

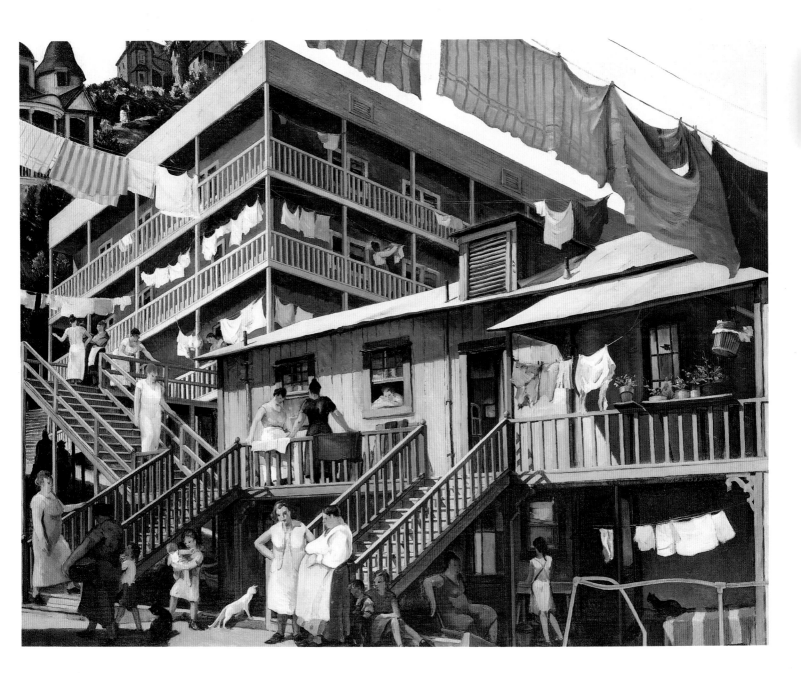

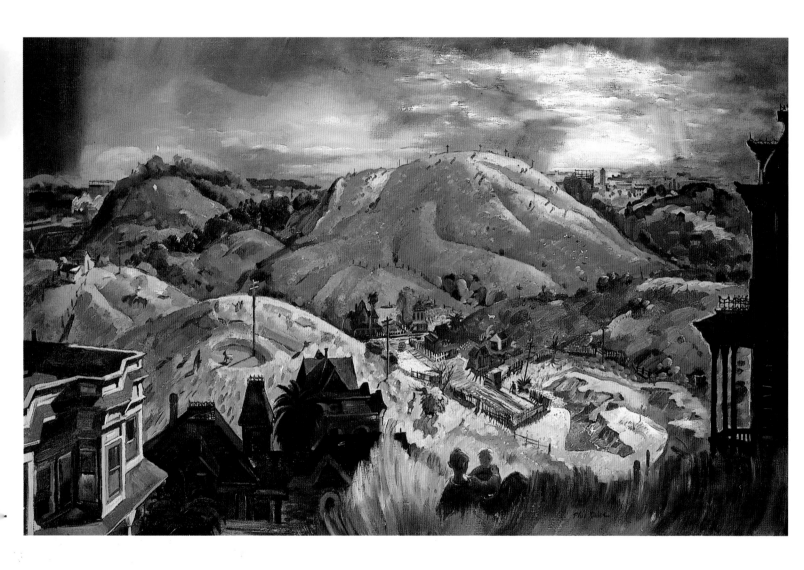

PHIL DIKE, View of Los Angeles (Chavez Ravine), 1943, Oil on canvas, 22 x 35 inches

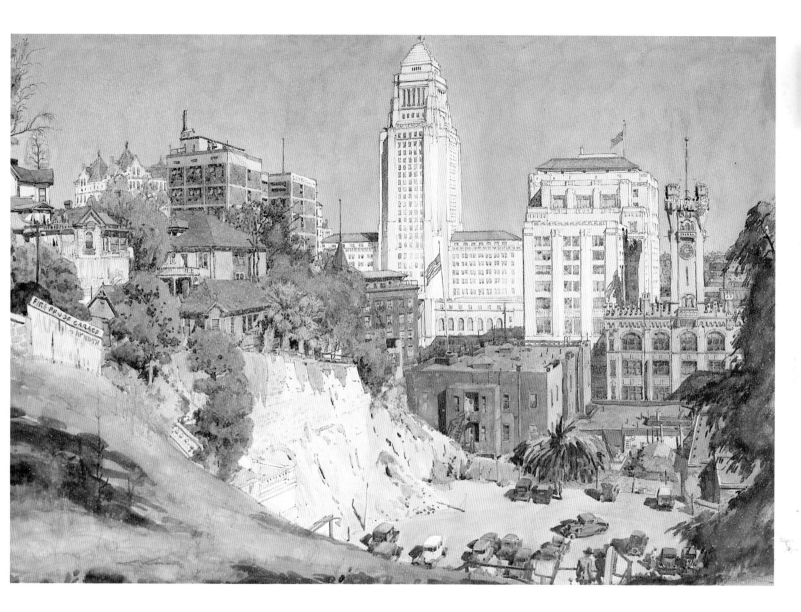

EMIL JEAN KOSA, JR., Untitled (Los Angeles City Hall and Times Building from Bunker Hill), c. 1931, Watercolor on paper, 14½ x 20¾ inches

THE CABLE-CARS HAVE FOR ALL PRACTICAL PURPOSES
made San Francisco a dead level. They take no count of rise or fall, but slide equably on their
appointed courses from one end to the other of a six-mile street. They turn corners almost
at right angles; cross other lines, and, for aught I know, may run up the sides of houses.

There is no visible agency of their flight; but once in a while you shall pass a
five-storied building, humming with machinery that winds up an everlasting wire-cable, and
the initiated will tell you that here is the mechanism. I gave up asking questions. If it pleases
Providence to make a car run up and down a slit in the ground for many miles, and if for
two-pence-halfpenny I can ride in that car, why shall I seek the reasons of the miracle?

RUDYARD KIPLING, *In San Francisco*, 1889

LEE BLAIR, San Francisco Cable Car Celebration, c. 1938, Watercolor on paper, 15 x 21½ inches

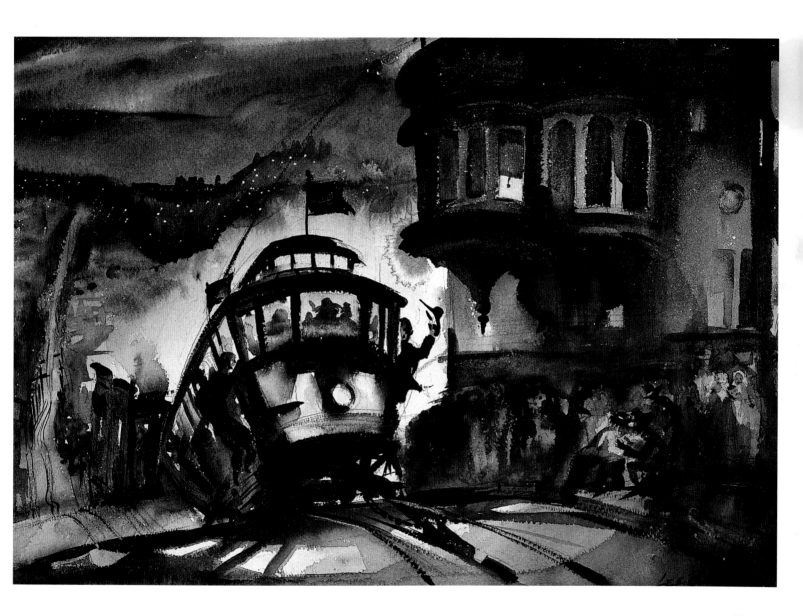

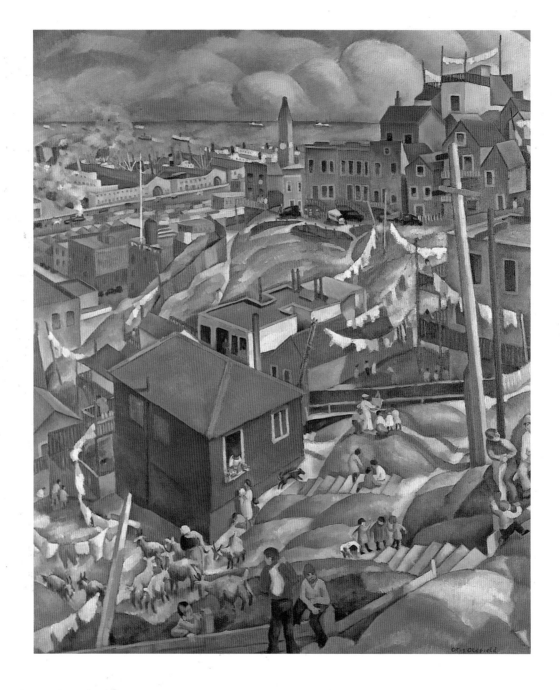

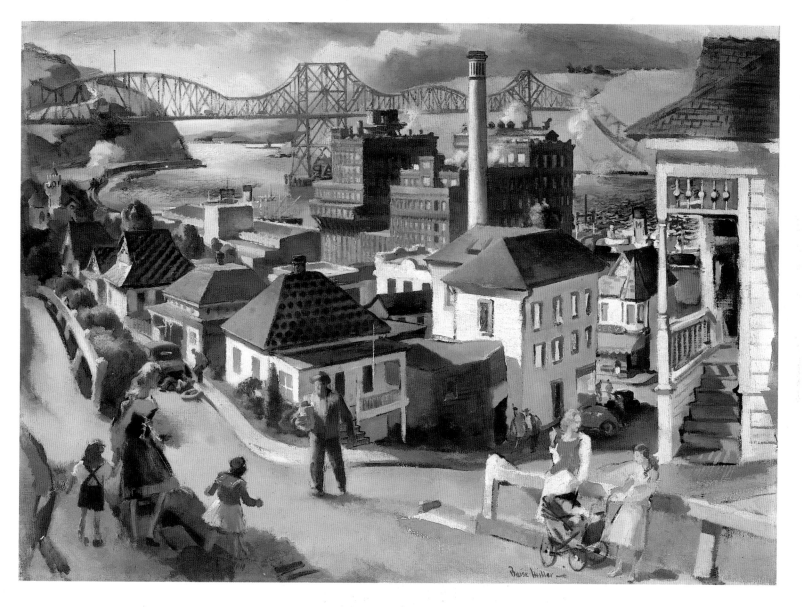

BARSE MILLER, Factory Town, 1946, Oil on canvas, 26 x 36 inches

OTIS OLDFIELD, Telegraph Hill, c. 1927, Oil on canvas, 40 x 33 inches (*opposite*)

THE ASPECT OF NATURAL OBJECTS UP AND DOWN
the Pacific Coast is as "aristocratic" as the comprehensive American condition permits anything
to be: it indeed appears to the ingenious observer to represent an instinct on the part of Nature,
a sort of shuddering, bristling need, to brace herself in advance against the assault of a society so
much less marked with distinction than herself.

HENRY JAMES

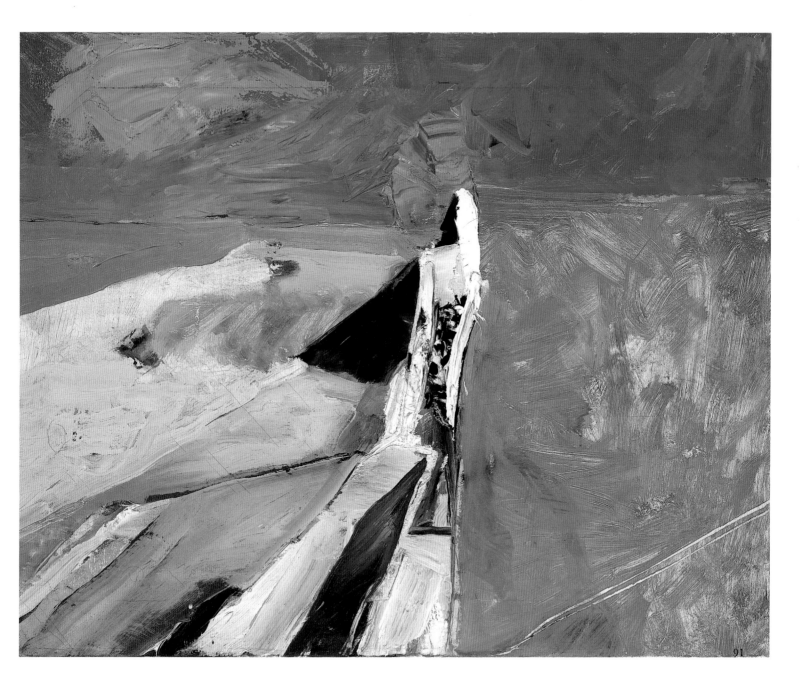

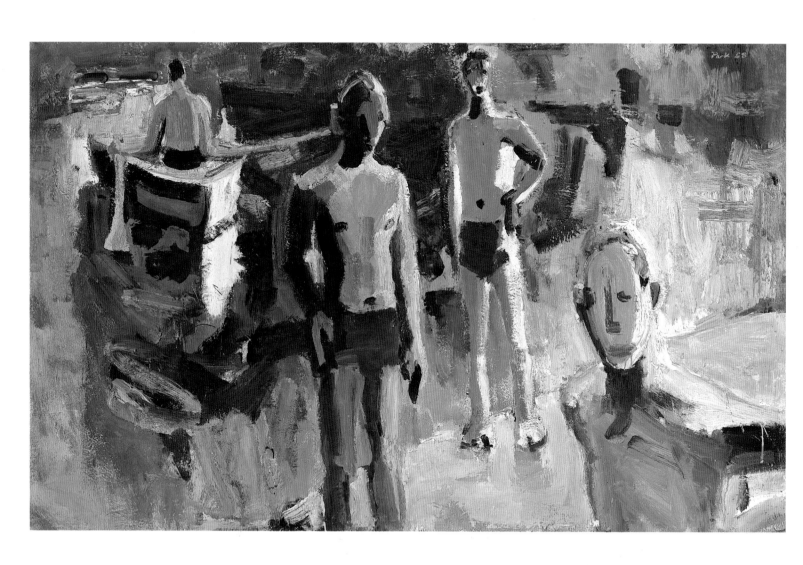

DAVID PARK, Four men, 1958, Oil on canvas, 57 x 92 inches

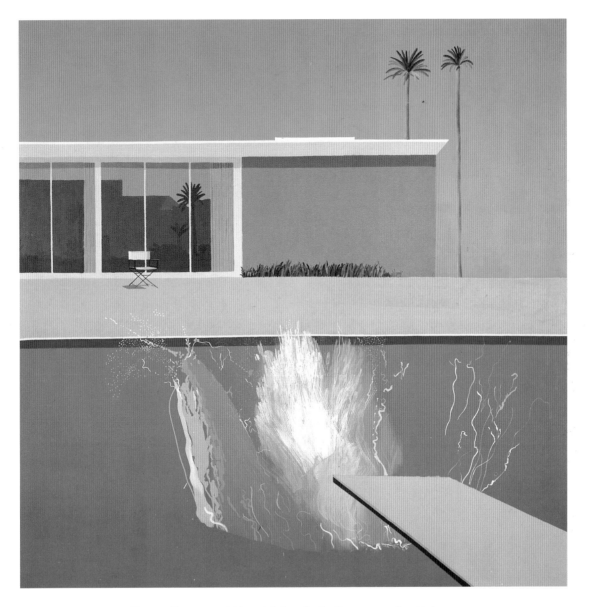

D AVID H OCKNEY, A Bigger Splash, 1967, Acrylic on canvas, 96 x 96 inches

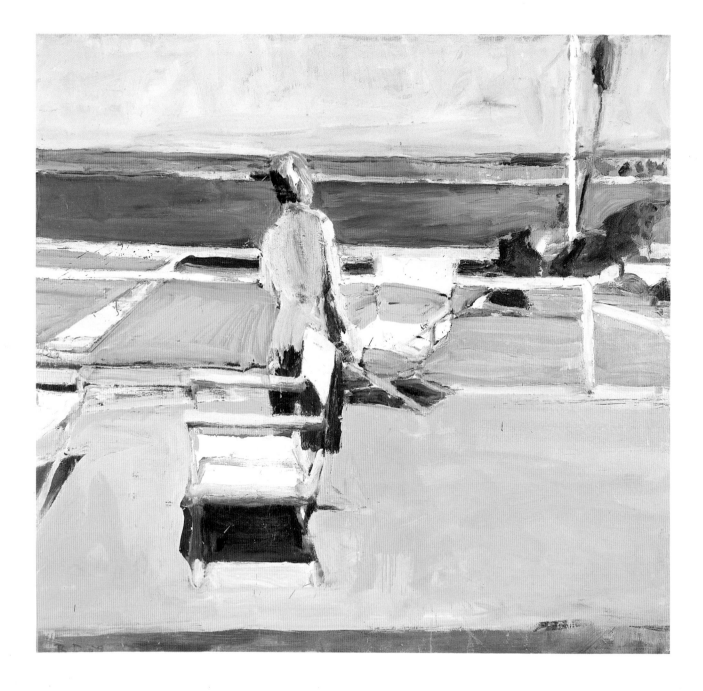

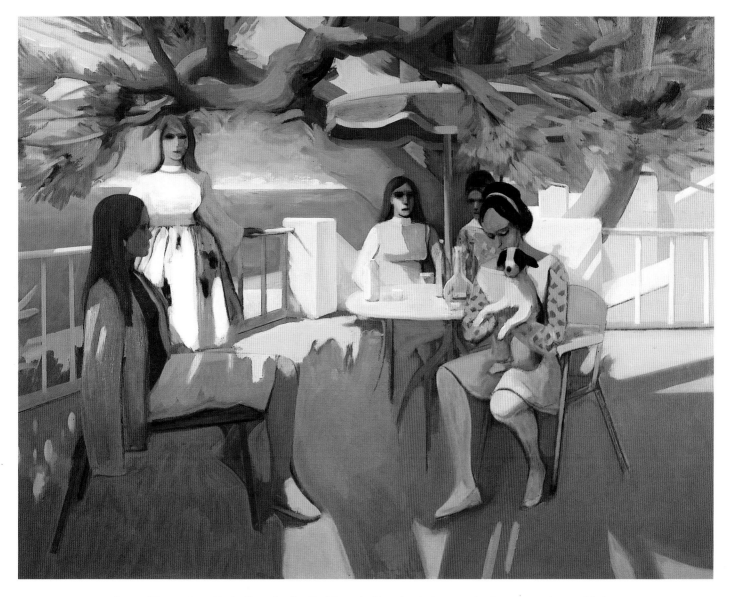

JAMES WEEKS, Santa Monica Easter Sunday (Models on the Terrace) 1967-69-71-73, Acrylic on canvas, 69¾ x 90 inches

RICHARD DIEBENKORN, Figure on a Porch, 1959, Oil on canvas, 57 x 62 inches (*opposite*)

SIMEON LAGODICH
Lake Hollywood, Late Afternoon, 1988
Oil on canvas, 22 x 50 inches

AUTUMN in California is a mild
And anonymous season, hills and valleys
Are colorless then, only the sooty green
Eucalyptus, the conifers and oaks sink deep
Into the haze; the fields are plowed, bare, waiting;
The steep pastures are tracked deep by the cattle;
There are no flowers, the herbage is brittle.
All night along the coast and the mountain crest
Birds go by, murmurous, high in the warm air.
Only in the mountain meadows the aspens
Glitter like goldfish moving up swift water;
Only in the desert villages the leaves
Of the cottonwoods descend in smoky air.

KENNETH REXROTH, *Autumn in California*, 1940

WILLARD DIXON, Petaluma Fields, 1987, Oil on canvas, 72 x 108 inches

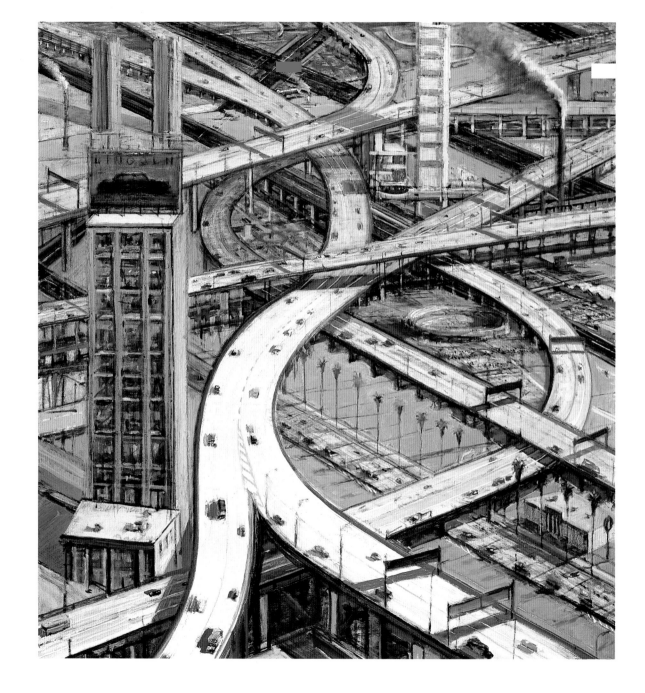

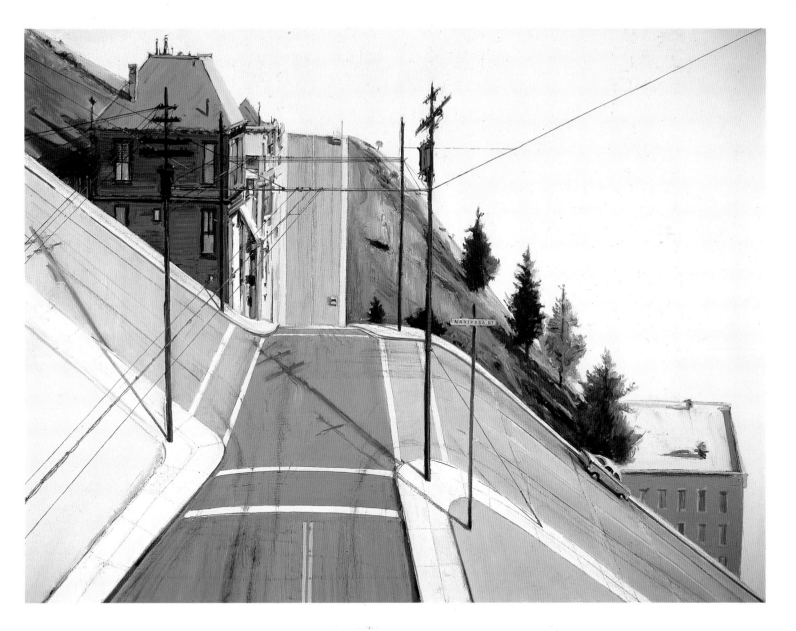

Wayne Thiebaud, 24th Street Intersection (Twenty-Fourth St. Ridge), 1977, 35 ½ x 48 inches

Wayne Thiebaud, Urban Freeways, 1979/1980, Oil on canvas, 44 ¼ x 36 inches (*opposite*)

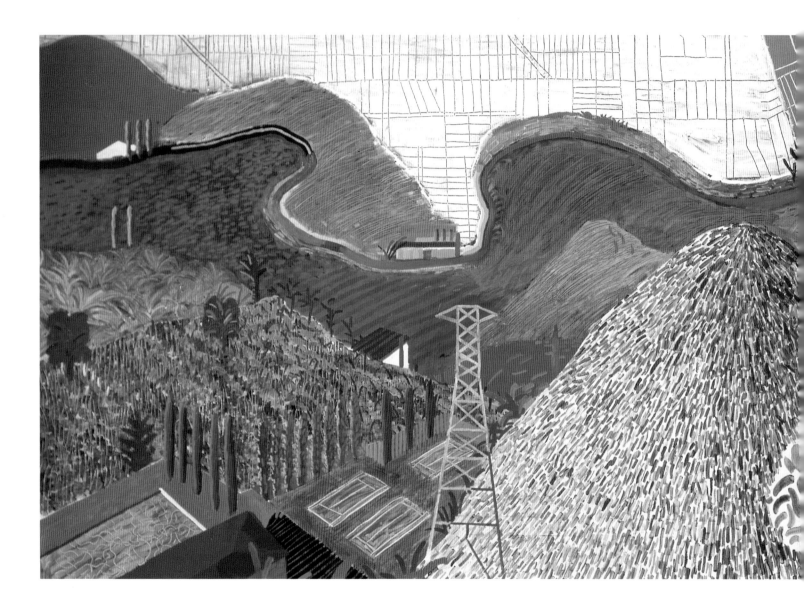

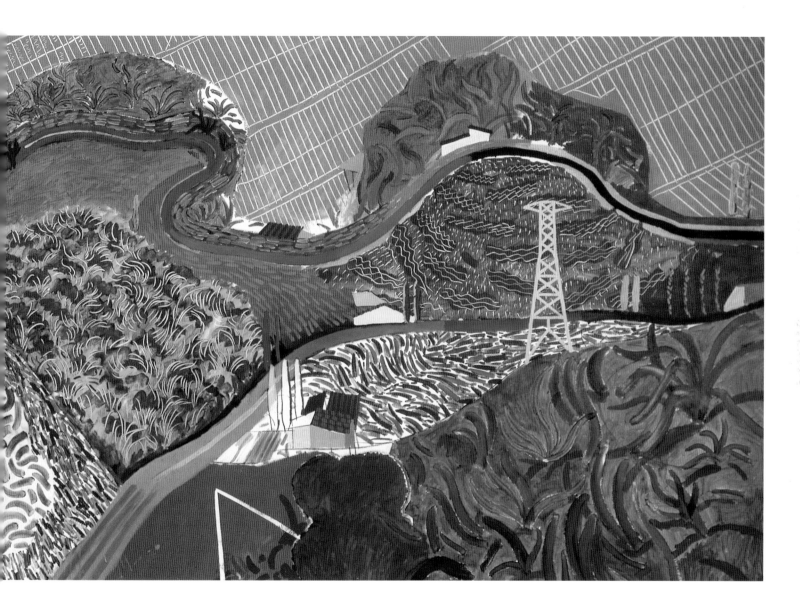

DAVID HOCKNEY, Mulholland Drive: The Road to the Studio, 1980, Acrylic on 2 canvases, 86 x 243 inches

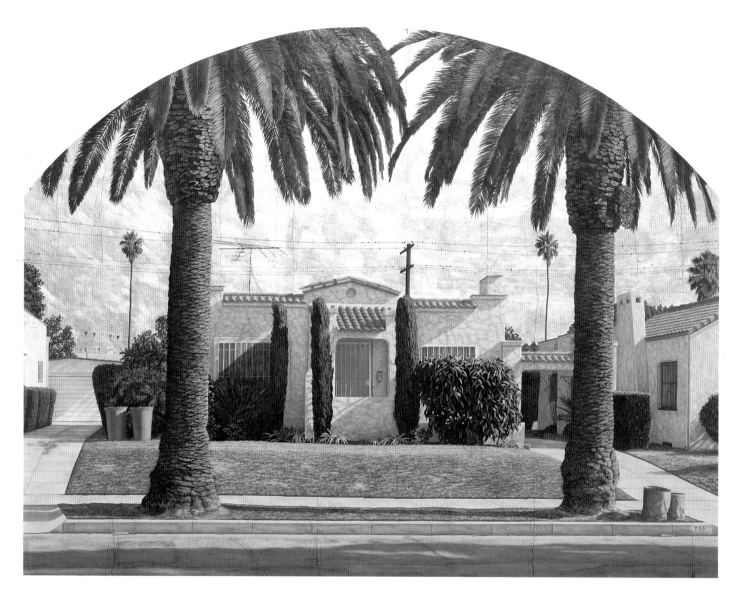

ROBERT GINDER, Blue House, 1992, Oil and gold leaf on wood, 40½ x 53 inches

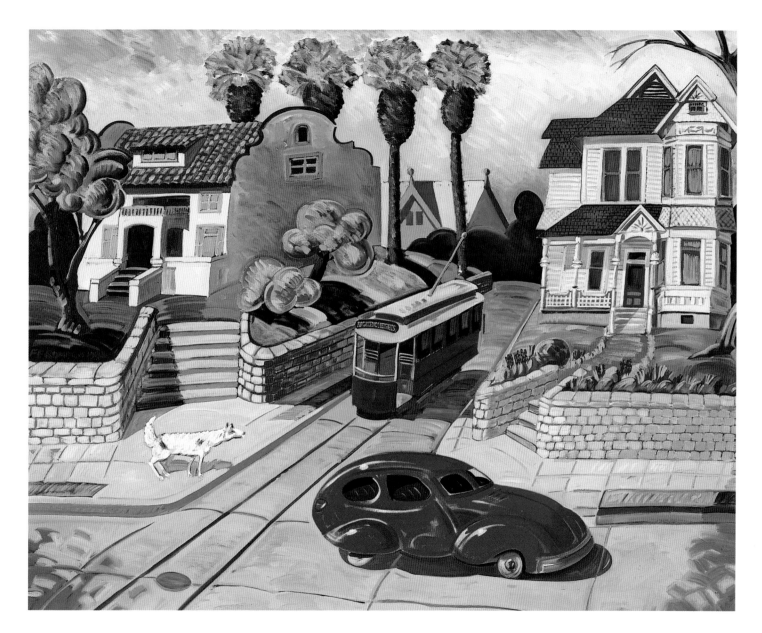

FRANK ROMERO, Angelino Heights, 1986, Oil on canvas, 48 x 60 inches

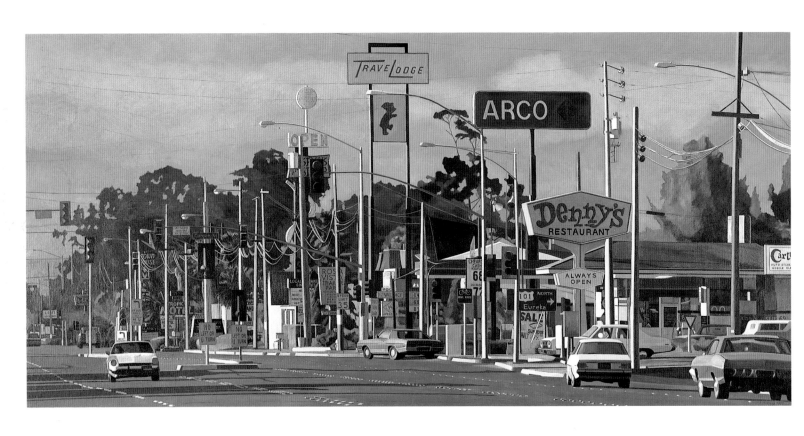

STEPHEN HOPKINS, Denny's Arco, 1987, Oil with alkyd medium on linen, 32½ x 71½ inches

ROBERT COTTINGHAM, Barrera-Rosa's, 1985, Oil on canvas, 59 x 168 inches (*opposite*)

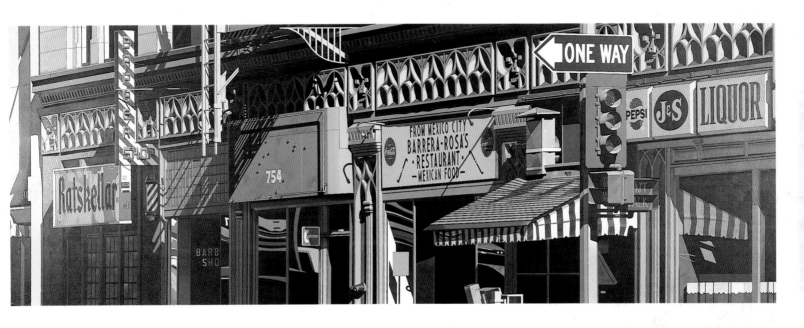

THE STRIP.

Saturday morning. Mexican restaurants, Adelita's, La Iguana de Oro, The Latin Strip,
dime stores, pawn shops, radio and television repair, finance companies, Woolworth's,
J. C. Penney, Sears, Jack-In-The-Box, McDonald's, Department of Social Welfare,
Hollenbeck Police Station. We cross Atlantic, Olympic, Indiana, Brooklyn, Soto....

OSCAR ZETA ACOSTA, *The Revolt of the Cockroach People*, 1973

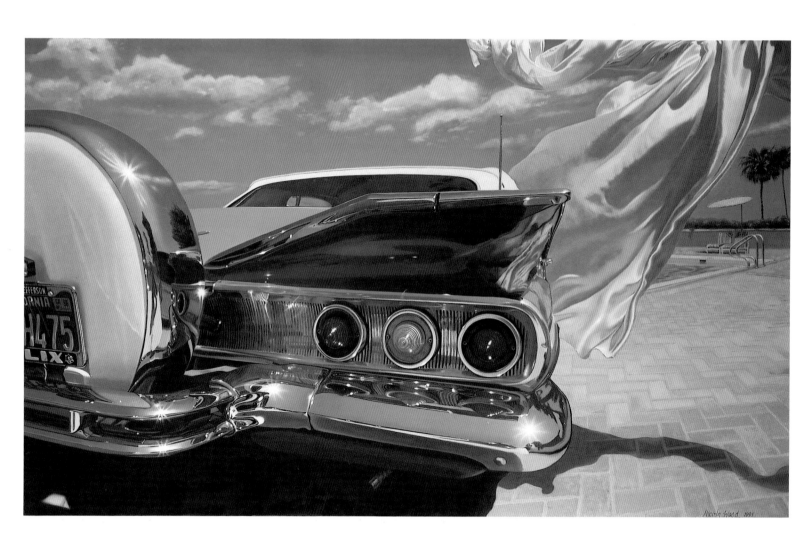

NICOLA WOOD, '60 Chevy, 1991, Oil on canvas, 36 x 60 inches

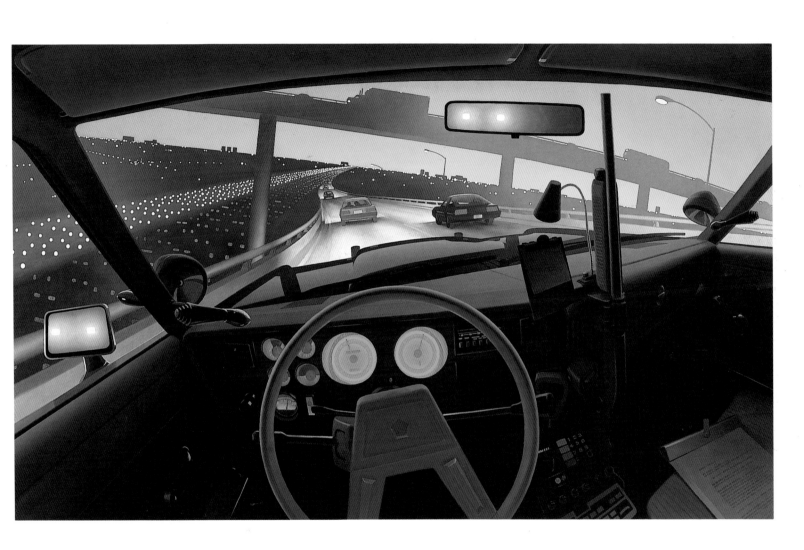

JAMES DOOLIN, Highway Patrol, 1986, Oil on canvas, 72 x 118 inches

RELJA PENEZIC, Highway One #1, 1992, Oil on canvas, 24 x 36 inches

CALIFORNIA IS A QUEER PLACE
— in a way, it has turned its back on the world,
and looks into the void Pacific.

D. H. LAWRENCE

BRUCE EVERETT, May Canyon, 1987
Oil on canvas, 78 x 56 inches

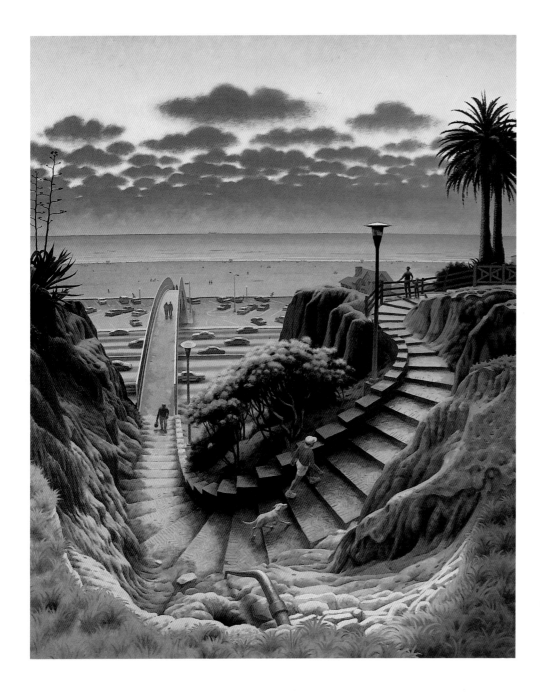

JAMES DOOLIN, Stairway, 1991-92
Oil on canvas, 90 x 72 inches

ASTRID PRESTON, Mountain Path, 1989
Oil on canvas, 96 x 72 inches

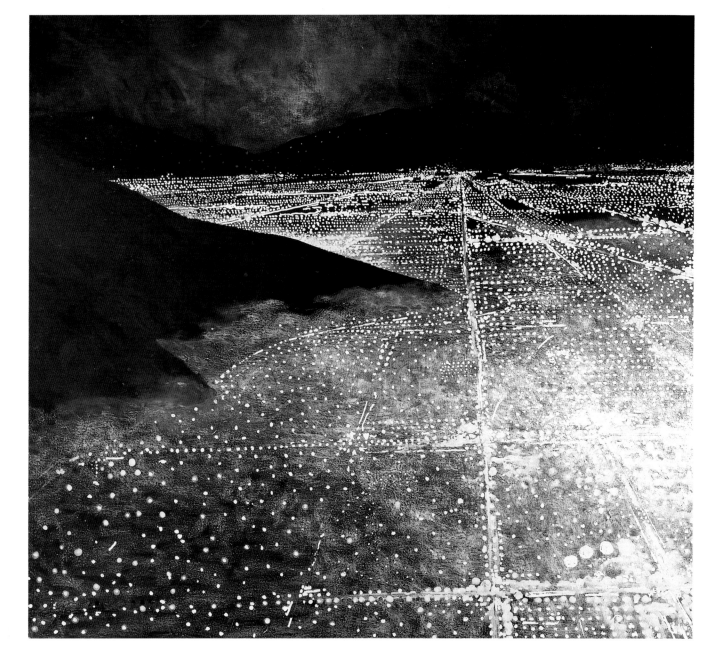

THERE IS NOTHING TO MATCH FLYING OVER LOS ANGELES BY NIGHT.
A sort of luminous, geometric, incandescent immensity, stretching as far as the eye can
see, bursting out from the cracks in the clouds. Only Hieronymus Bosch's hell can match this
inferno effect. The muted fluorescence of all the diagonals: Wilshire, Lincoln, Sunset,
Santa Monica. Already, flying over San Fernando Valley, you come upon the horizontal infinite
in every direction. But, once you are beyond the mountain, a city ten times larger hits you.
You will never have encountered anything that stretches as far as this before. Even the sea cannot
match it, since it is not divided up geometrically. The irregular, scattered flickering of European
cities does not produce the same parallel lines, the same vanishing points, the same aerial
perspectives either. They are medieval cities. This one condenses by night the entire
future geometry of the networks of human relations, gleaming in their abstraction, luminous
in their extension, astral in their reproduction to infinity. Mulholland Drive by
night is an extraterrestrial's vantage point on earth, or conversely, an earth dweller's
vantage point on the galactic metropolis.

JEAN BAUDRILLARD, *America*, 1986

PETER ALEXANDER, Van Nuys, 1987, Oil and acrylic on canvas, 60 x 66 inches 115

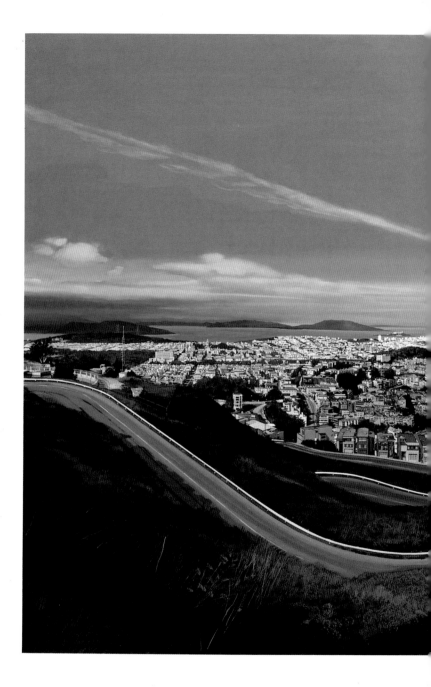

CALIFORNIA BECAME, AS IT HAD TO,
the New World's New World, its last repository of
hope. In California, you come face to face with the
Pacific and yourself. There is nowhere else to go. Just as
both Los Angeles and San Francisco are, in their
separate ways, recognizably Californian, so is California
recognizably American. All that California does is
magnify what is brought to it; and often, under the
strain of magnification, there occurs a sea change. It
seems that those whom the gods wish to destroy they
first send to California.

SHIVA NAIPAUL,
Journey to Nowhere: A New World Tragedy, 1980

RICHARD ESTES, *View from Twin Peaks*, 1990
Oil on canvas, 36 x 72 inches

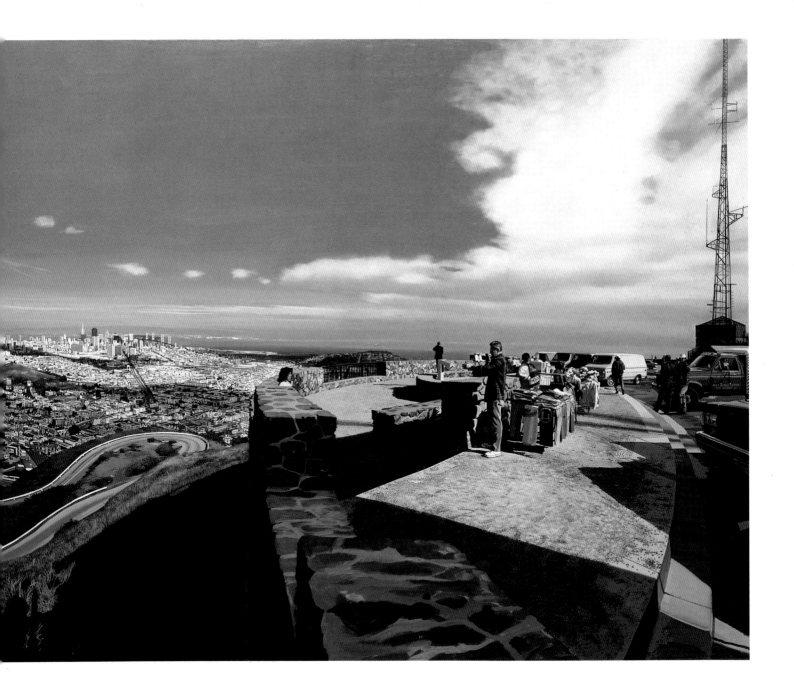

Artists' Biographies

PETER ALEXANDER (b. 1939). Native Los Angeles artist; 1970s turned to landscape painting; now explores urban sprawl of southern California, basing his views on nighttime aerial photography; lives in Malibu.

STANDISH BACKUS, JR. (1910–1989). Santa Barbara watercolorist; 1935 settled in California; painted landscapes and figures in American Scene tradition.

GEORGE BELLOWS (1882–1925). New York-based realist painter; 1917 summered at Carmel, visiting nearby Pebble Beach and Point Lobos, painting the coast; fascinated by the color, luminosity, and fog.

THOMAS HART BENTON (1889–1975). Foremost Regionalist, active in New York then in Missouri; sent to Hollywood in 1937 by *Life* magazine; 1946, worked with Walt Disney.

ALBERT BIERSTADT (1830–1902). Leading landscape painter of the West; 1863 first visited San Francisco and Yosemite. Identified with highly detailed, large-scale, theatrical views of the Yosemite Valley and Sierra Nevada.

ELMER BISCHOFF (b. 1916). Berkeley born and trained; leading early Bay Area figurative painter; began working representationally in 1952.

LEE BLAIR (b. 1911). California-born watercolorist; in Los Angeles, he created bustling genre scenes; a leader in the animation and film industry; lives near Santa Cruz.

RALPH ALBERT BLAKELOCK (1847–1919). New York-based visionary landscape painter; during 1869 trip to the West, traveled along the coast of California and painted Seal Rocks near San Francisco's Ocean Beach.

MAURICE BRAUN (1877–1941). Born in Hungary; figure painter in New York prior to settling in California in 1910; with light-filled landscapes expressing theosophical principles, he became first San Diego artist to receive national attention.

LT. GEORGE D. BREWERTON (1827–1901). Trained at West Point in topographical drawing; 1847 visited California as second lieutenant. 1848, with Kit Carson, he rode west with news of the discovery of gold from San Francisco to Santa Fe through the Mojave Desert; landscape painter and author.

FREDERICK BUTMAN (1820–1871). Native of Maine, he was in San Francisco from 1857 to 1871; one of first California artists devoted exclusively to landscape; depicted Yosemite, Lake Tahoe, Mount Shasta, etc.

ROBERT COTTINGHAM (b. 1935). Brooklyn-born Photorealist; late 1960s art director in advertising; teacher; fascinated by abstract forms of commercial signs, neon lights, and boxcars.

WILLIAM A. COULTER (1849–1936). Native of Ireland; one of San Francisco's earliest artists; as a ship portraitist and marine painter, he chronicled the shipping industry of the Bay Area.

TOM CRAIG (1909–1969). Born in Upland and based in southern California; painted the moods of California nature during 1930s and 1940s; watercolors earned him appellation, "Master-of-mist-and-water."

RICHARD DIEBENKORN (1922-1993). Leading California contemporary modernist; trained in northern California, first known as a San Francisco Bay Area expressionist; 1966–1973 taught at UCLA; early 1960s turned to urban landscapes; now identified with abstract interpretations of California's open space and light.

PHIL DIKE (1906–1990). Prominent southern California regionalist of 1930s and 1940s; best known for city views; active in California Watercolor Society; also teacher and color advisor for animated film studios.

WILLARD DIXON (b. 1942). Based and taught in northern California during 1970s and 1980s; paints large, detailed landscapes; concerned with atmosphere, light, and weather; lives in San Rafael.

JAMES DOOLIN (b. 1932). Born in Hartford, Connecticut; has lived in California since receiving MFA from UCLA in 1971; known for his desert and urban landscapes.

FANNIE ELIZA DUVALL (1859 or 1861–1934). New York-born and trained; first settled in Los Angeles in late 1880s; worked also in Pasadena and Santa Barbara as figure, flora, and landscape painter.

RICHARD ESTES (b. 1932). Born in Illinois; studied art in Chicago; lives in New York and New England. His painting of San Francisco is part of an ongoing series of panoramic views of great cities.

BRUCE EVERETT (b. 1942). Native of Los Angeles; received MFA at the University of California at Santa Barbara; his work is described as "monumental photorealism of the California landscape."

JOHN FROST (1890–1937). Philadelphia-born landscape painter who studied in France; 1918 settled in Pasadena; noted for luminous views of the High Sierras, desert, and villages of southern California.

AUGUST GAY (1890–1949). French-born; about 1901 emigrated to Oakland; from 1917 leading member of Society of Six group of modernists; 1919 moved to Monterey.

SELDEN CONNOR GILE (1877–1947). Maine-born modernist; settled in California in 1901; founder of Oakland Society of Six group; brilliant colorist and landscapist.

ROBERT GINDER (b. 1948). Raised in Los Angeles; late 1970s and 1980s worked in San Diego; explores the unique architecture of southern California, in particular the California bungalow; lives in New York.

WILLIAM HAHN (1829–1887). German painter. Active in northern California from 1872 to 1882; San Francisco's earliest genre painter; known for street scenes and detailed landscapes with animals.

ARMIN HANSEN (1886–1957). Native Californian, who, in 1913, after a career in Europe, moved permanently to Monterey; known for powerful seascapes and genre scenes of fishermen.

ALEXANDER HARMER (1856–1925). Southern California's first significant painter, arriving in the early 1890s; active in Santa Barbara; specialized in genre scenes of early Mexican life in the state.

CHILDE HASSAM (1859–1935). Leading American Impressionist; 1914 visited San Francisco to complete a lunette for the Panama-Pacific International Exposition of 1915, and made painting excursions to Carmel and locales in southern California.

THOMAS HILL (1829–1908). English born; major California landscape painter; traveled West in 1861 and became a leading San Francisco artist during 1870s; first permanent studio in Yosemite in 1888; popularized California through panoramic views and depictions of the sequoias.

DAVID HOCKNEY (b. 1937). English-born artist; settled in Los Angeles 1964–1968 and began first California images of swimming pools, with which he became best identified; resident of Los Angeles since 1976.

STEPHEN HOPKINS (b. 1934). Born in Boston; educated at Harvard; teacher of painting since 1969; resides in San Francisco Bay area since 1976; paints the urban landscape.

GEORGE INNESS (1825–1894). Foremost East Coast-based landscapist; in 1891 shared William Keith's San Francisco studio and sketched with him in Monterey and Yosemite. His poetic interpretations of nature influenced a generation of northern California artists.

WILLIAM KEITH (1838/39–1911). Major California landscape painter; Scottish-born, he first visited the state in 1858 as a *Harper's* illustrator; 1860s studied with Charles Nahl; 1872 moved to San Francisco. His realistic, scenic interpretations became moodier and more tonalist after sharing his studio with George Inness.

JOSEPH KLEITSCH (1882–1931). Hungarian-born portrait painter who came to southern California in 1920 for a commission; in Laguna Beach turned to landscape painting; with jewel-like palette and vigorous brushwork captured the sparkle of coastal regions.

EMIL J. KOSA, JR. (1903 – 1968). Settled permanently in Los Angeles in 1928, after studying in Europe; best known for city views and landscapes painted boldly with intense light and color.

SIMEON LAGODICH (b. 1954). Born and studied in Wisconsin, lives in New York. His first visit to Los Angeles was in 1985, with frequent visits from 1987 to 1991.

JOSEPH LEE (1827 – 1880). Born in England; 1858 in San Francisco as sign and ornamental painter; painted meticulous, charming ship and house portraits, town views, and landscapes, largely of Alameda County.

FERNAND LUNGREN (1859 – 1932). Foremost desert painter of early twentieth century; in Los Angeles from 1903 to 1906, settled in Santa Barbara; famous for depictions of Mojave Desert and Death Valley.

WILLIAM MARPLE (1827 – 1910). Landscape painter; 1849 miner during Gold Rush; 1866 and 1877 active in San Francisco as artist; 1872 opened art importing firm; known for silvery grey lighting effects.

ARTHUR F. MATHEWS (1860 – 1945). Raised in Oakland; most significant artist at turn-of-the-century, inspiring a generation of northern California artists; established the decorative aesthetic movement in the state; known for tonalist landscapes of northern California and lyrical, idealized figure compositions.

WILLIAM McILVAINE (1813 – 1867). New York-based landscape artist; 1849 briefly visited gold mines and sketched around the Tuolumne and Merced Rivers.

BARSE MILLER (1904 – 1973). Prominent California Scene painter during 1930s and 1940s; 1924 settled in Los Angeles; worked in both oils and watercolor; returned to native New York after World War II.

ALFRED R. MITCHELL (1888 – 1972). Dean of San Diego artists prior to World War II; 1908 settled in California and 1913 studied with Maurice Braun; mainly painted landscapes of San Diego and its backcountry.

CHARLES CHRISTIAN NAHL (1818 – 1878). German-born classical-trained figure painter; moved to California 1851 where he became one of the first professional painters; painted life of the miners and *rancheros*.

EUGENE NEUHAUS (1879 – 1963). Landscape painter born and trained in Germany; 1904 moved to San Francisco; founder of Del Monte Art Gallery in Monterey; also teacher, but best known as author of several books on American and California art.

OTIS OLDFIELD (1890 – 1969). Figure painter born in Sacramento; returned to San Francisco in 1924 after a decade in Paris; known for modernist city views of the Embarcadero and the Bay painted from his studio on Telegraph Hill.

PHIL PARADISE (b. 1905). Leading California Regionalist and major watercolorist; 1930s and 1940s painted urban and industrial Los Angeles environs and bucolic landscapes of rural life; his images of spirited horses were considered typically Californian.

DAVID PARK (1911 – 1960). Preeminent Bay Area painter; Boston-born, but trained in Los Angeles in 1929; brought northern California contemporary art scene to national attention with brilliantly lit, figurative, action painting.

RELJA PENEZIC (b. 1950). Native of Belgrade, Yugoslavia. Came to the United States in 1985; moved to California in 1991; resides in San Francisco and concentrates on the California scene.

ASTRID PRESTON (b. 1945). Born in Sweden; resident of southern California since 1952; contemporary painter with emphasis in landscape.

GRANVILLE REDMOND (1871 – 1935). Major California *plein-air* painter; raised in San Jose and trained in San Francisco and Paris; painted tonalist and impressionist landscapes from Tiburon to Laguna Beach; best known for images of poppy fields.

CHARLES REIFFEL (1862 – 1942). Successful lithographer and painter in Cincinnati, New York, and Connecticut before settling in California; major landscapist in San Diego from 1925 identified with vigorously brushed views of southern California.

WILLIAM RITSCHEL (1864 – 1949). Carmel-based painter of the sea; famous for vigorously recording the coastal peninsula – its trees, cliffs, surf in fog – at night, and in the glare of white light.

JULIAN WALBRIDGE RIX (1850 – 1903). Landscape painter active late 1860s and 1870s in San Francisco and Monterey; continued to paint California scenes after he moved East; 1901 painted near Monterey and Santa Barbara. His panoramic landscapes and sunsets are characterized by poetic use of atmosphere and light.

FRANK ROMERO (b. 1941). Prominent Hispanic artist; Los Angeles native and member of art collective *Los Four* in 1974; working in many media; known for personal iconography based on his ethnic roots and contemporary concerns specific to urban California.

GUY ROSE (1867 – 1925). First native-born southern California artist to achieve international fame; foremost California Impressionist; after living in Giverny, France, returned in 1914; painted in Pasadena, Laguna Beach, and Carmel, both coastal and inland scenes.

EDWARD RUSCHA (b. 1937). One of Los Angeles's most famous contemporary artists; native of Omaha, he moved to California in 1956; as a Pop artist transformed the banal signs and images of Los Angeles – billboards, gas stations – into idealized symbols.

PAUL SAMPLE (1896 – 1974). American Scene painter active in Los Angeles from 1925 to 1938; along with friend Millard Sheets depicted contemporary urban life, often commenting on such problems as unemployment with a critical Social Realist overtone.

MILLARD SHEETS (1907 – 1989). Foremost California Scene painter; 1930s depicted urban Los Angeles; captured spirit of California in brilliantly hued, stark land-scapes; as a teacher and decorative designer influenced next generation of southern California artists.

ALEXIS SMITH (b. 1949). Los Angeles-born conceptual artist; often derives themes for collages, constructions, and installations from American popular culture as manifested in Hollywood films, and other southern California experiences; lives in Venice, California.

WAYNE THIEBAUD (b. 1920). Pop interpreter of California's highways and urban streets; 1966 began depicting rural Sacramento Valley; early 1970s turned to San Francisco's unique topography; since 1960 teaches.

GEORGE TIRRELL (c. 1826 – unknown). Massachusetts-born landscape painter active in northern California in late 1850s; best known for panorama illustrating California from Monterey to Yosemite.

ELMER WACHTEL (1864 – 1929). Southern California *plein-air* painter; 1882 moved to San Gabriel Valley; late 1890s illustrator for *Land of Sunshine* and *Californian* magazines; 1901 established himself as a painter; lived with wife, watercolorist Marion Wachtel, in Arroyo Seco area.

JAMES WALKER (1819 – 1889). English-born artist of battle scenes; by 1870 established first studio in San Francisco; unique in depicting the lifestyle of the Spanish Californian *vaquero*.

THADDEUS WELCH (1844 – 1919). Indiana-born landscape painter; after extensive study and travel throughout the world, settled in San Francisco in 1894; achieved critical and financial success with realistic, yet lyrical panoramas of Marin County, often including cattle.

JAMES WEEKS (b. 1922). Born in Oakland, studied in San Francisco, lived and taught in the Bay area from 1951 to 1967, then in Los Angeles until 1970; resides in Massachusetts.

FREDERICK AUGUST WENDEROTH (1819 – 1884). German-trained landscape painter; 1851, with Nahl arrived in California to search for gold; a daguerrotypist and painter in San Francisco; contributed backgrounds to Charles Nahl's figure paintings.

WILLIAM WENDT (1865 – 1946). Preeminent early 20th-century landscape painter; after a career in Chicago, became one of the first professional artists to settle in Southern California; focused on summer and autumn views of rolling hills, infusing them with power and religious spirit.

PAUL WONNER (b. 1920). Landscape, still life and figure painter; 1937 – 1946 and 1950 – 1963 resided in northern California; emerged from Bay Area figurative school, adopting its cold brilliant light.

NICOLA WOOD (b. ?) Born in England; moved to Los Angeles in 1976; specializes in photorealist depictions of automobiles.

THEODORE WORES (1859 – 1939). San Francisco-based figure and landscape painter; 1881 began specializing in Oriental genre scenes of San Francisco's Chinatown.

Selected California Museums

CROCKER ART MUSEUM
216 O Street
Sacramento, CA 95814
Tel. 916-264-5423
crocker@sacto.org.

The Crocker Art Museum is the oldest public art museum in the West, a Victorian masterpiece preserved and restored to enjoy today and for generations to come. Today, the Museum is best loved for its spectacular Victorian architecture, the Early California painting collection, Old Master Drawings and colorful contemporary art. The Crocker Art Museum also features Sunday concerts September through May; lectures; special events; Third Thursday Jazz concerts and Saturday afternoon family programs year-round.

Hours & Admission: Tues.-Sun. 10:00-5:00; Thurs. 10:00-9:00; Closed Mondays and major holidays. $4.50 for adults; $2.00 ages 7 to 17; ages 6 and under free.

THE CALIFORIA HISTORICAL SOCIETY
678 Mission Street
San Francisco, CA 94105
Tel. 415-357-1848 / Fax—1850
Email:info@calhist.org
Web: http://www.calhi

The California Historical Society is the state's official historical society, dedicated to collecting, preserving, interpreting, exhibiting, and disseminating information about California history. The Society maintains one of the largest library collections on California history in the state and publishes *California History*, a quarterly journal devoted to scholarly articles on California and the West. The Society's fine arts collections consist of oil paintings, watercolors, drawings, and an extensive grouping of prints including rare lithographs, letterheads, wood and steel engravings, woodcuts and etchings.

The museum is open Tues.-Sat., 11-5. The library is open on Wed. by appointment only. The administrative offices are open 9-5.

LOS ANGELES COUNTY MUSEUM OF ART
5905 Wilshire Blvd.,
Los Angeles, CA 90036
Tel. 213-857-6111

Five museum buildings, housing over 150,000 works spanning the history of art from ancient times to the present, surround a spacious central court. The Ahmanson Building contains the permanent collection of painting, sculpture, graphic arts, costumes, textiles, and decorative arts. The Hammer Building hosts major special loan exhibitions, while the Robert O. Anderson Building features the Museum's collection of 20th-century painting and sculpture as well as special loan exhibitions. The B. Gerald Cantor Sculpture Garden features bronze sculptures by the 19th-century French master Auguste Rodin. The 600-seat Leo S. Bing Center theater presents lectures, films and concerts. The Pavilion for Japanese Art houses the renowned Shin'enkan Collection of Japanese Edo-period paintings as well as Japanese ceramics, lacquerware, screens, scrolls, prints, and the Bushell Collection of netsuke. A variety of tours are offered daily and the Museum also gives tours for fourth through twelfth-grade classes.

Hours & Admission: 10:00-5:00 Tues.-Thurs., Fri. 10:00-9:00; Sat. and Sun. 11:00-6:00; closed Mon. and major holidays. $6 for adults, $4 for students with ID and senior citizens over 62 and $1 for children ages 6-17. Museum members and children under 6 admitted free. The second Wednesday of each month is free for all, except for some ticketed special exhibitions.

STANDISH BACKUS, JR., Santa Marguerita Grade, 1939, Watercolor, 15 x 22 inches

THE FINE ARTS MUSEUMS OF SAN FRANCISCO
M. H. de YOUNG MEMORIAL MUSEUM
Golden Gate Park. San Francisco, CA 94118
Tel. 415-750-3600 and 415-863-3330

The American canvas is well represented at the de Young. Almost 1,000 works present a continuous spectrum of American paintings from its earliest days through the mid-twentieth century—from *The Mason Children* of 1670 attributed to the Freake-Gibbs Painter, to Joshua Johnson's *Letitia Grace McCurdy* (a work by the first recorded artist of African American descent), through George Caleb Bingham's 1846 *Boatmen On the Missouri,* Georgia O'Keeffe's 1925 *Petunias,* and Grant Wood's Regionalist masterwork, *Dinner for Threshers,* of 1934. The works of certain artists, notably Albert Bierstadt, Eastman Johnson, and John Singer Sargent provide a microcosmic view of an entire career. Galleries of contemporary art feature works by Bay Area artists, with major examples by Wayne Thiebaud and Richard Diebenkorn. In the Gallery of the Americas are objects of the highest calibre from Mesoamerica, Central and South America, as well as the West Coast of North America. The African art gallery brings to light the aesthetic power of works from many areas of sub-Saharan Africa. Throughout the year changing exhibitions from the museum's world-renowned textile collection are also presented.

Hours & Admission: Wed-Sun., 9:30-5:00; closed Mon. and Tues. Adult, $6; Senior (65 and over), $4; Youth (12-17) $3. Under 12 free. One fee enables visits to two museums in the same day: de Young and Asian Art Museum (in the same building).

LAGUNA ART MUSEUM
307 Cliff Drive
Laguna Beach, CA 92651
Tel. 714-494-6531

The Laguna Art Museum, which celebrated its 75th anniversary in 1993, collects, exhibits and provides educational programs about American art, with a particular focus on the art and artists of California. Orange County's oldest cultural institution, the Museum remains dedicated to its traditional heritage while actively pursuing serious and provocative art of our times. Its exhibits range in content from American Impressionism to installation and performance art. The Museum's Education Department offers an extensive program of events to enrich the public's understanding and enjoyment of Museum collections and exhibitions from lectures and symposiums to art history classes and hands-on workshops for children and adults. Over 75,000 people are served each year, including 60,000 school children throughout the county who are served by "Art from the Museum," a special program that gives students of all backgrounds an introduction to the visual arts through a series of traveling exhibitions.

Hours & Admission: 11:00-5:00 daily; the Museum is closed on Mondays. $5, general; $3.00, students and seniors; free, children under 12 and Museum members. The bookstore is open during museum hours. The rental and sales gallery is open during museum hours and by appointment (714-494-6531).

MONTEREY MUSEUM OF ART
559 Pacific Street
Monterey, CA 93940
Tel. 408-372-5477 / Fax—5680

The Monterey Museum of Art has been called "the best small town museum in the United States." Seeking to enrich and educate through the arts, the exhibitions concentrate on the rich artistic heritage of this region. The museum's permanent collection includes California art, photography, Asian art, international folk art and features significant bodies of work by Armin Hansen, William Ritschel, Ansel Adams and Edward Weston. Located across from Colton Hall in the historic center of Monterey, the museum includes seven galleries, as well as an education center and library.

Hours: Wed.-Sat. 11:00-5:00, Sun. 1:00-4:00.

MONTEREY MUSEUM OF ART at LA MIRADA
720 Via Mirada
Tel: 408-372-6044 / Fax—6043

Surrounded by magnificent gardens and picturesque stone walls, the Monterey Museum of Art at La Mirada is situated in one of Monterey's oldest neighborhoods. Its history is colorful. It began as a two room adobe and later became an elegant home where international and regional celebrities were entertained. Vistors today will experience the same charming, exquisitely furnished home, spectacular rose and rhododendron gardens and the ambience of early California. With the addition of the Dart Wing in 1993, designed by renowned architect Charles Moore, visitors also view the museum's permanent collection and changing exhibitions in four contemporary galleries which complement the original estate.

Hours: Thurs.-Sat. 11:00-5:00, Sun., 1:00-4:00.

ORANGE COUNTY MUSEUM OF ART
850 San Clemente Drive
Newport Beach, CA 92660
Tel: 714-759-1122 / Fax—5623

The Orange County Museum of Art, in two locations, is dedicated to the collection, preservation, exhibition and interpretation of modern and contemporary art. The Museum's 6,500-piece collection of paintings, sculptures, photographs, works on paper and installations focuses on post World War II California art and includes works by John Baldessari, Billy Al Bengston, Chris Burden, Vija Celmins, Richard Diebenkorn, Joe Goode, Ed Ruscha, Edward Keinholz and Bill Viola. Changing exhibitions feature modern and contemporary artists from California, the United States and around the world and are designed to define current trends in art and place modern art in an historical context. The Museum offers exhibitions, tours, school programs, classes for young people and adults, outreach programs, popular and scholarly publications, performing arts programs, lectures, film and video events. The Museum Shop contains items for purchase which complement the Museum's collection and exhibitions.

OCMA in Newport Beach
Hours: Tuesday through Sunday, 11 a.m. to 5 p.m. *Admission:* $5 for adults, $4 for students and seniors, and free for children under 16 and OCMA members. *Public Tours:* Tuesday through Sunday, 1 p.m. *Location:* At the corner of Santa Barbara and San Clemente.
OCMA South Coast Plaza Gallery
Hours: 10 a.m. to 9 p.m. Monday through Friday; 10 a.m. to 7 p.m. Saturday; and 11:30 a.m. to 6:30 p.m. Sunday. *Admission:* Free. *Location:* Carousel Court entrance to the Plaza in Costa Mesa.

OAKLAND MUSEUM OF CALIFORNIA
1000 Oak Street
Oakland, CA 94607
Tel. 510-238-2200
(24-hour recorded information)

The Oakland Museum is a major regional museum dedicated to the art, history and ecology of California. The Art Department collects and exhibits paintings, sculpture, drawings, prints, photographs, crafts, decorative art objects and mixed-media pieces that reflect the cultural heritage of California from the period of early exploration, roughly 1815, to the present. The collection reflects the liveliness and breadth of the visual and plastic arts of California to an extent unmatched by any other museum collection. The underlying premise of the collection is that California's physical and cultural uniqueness makes an imprint on the artists who work here and they, in turn, imprint the history of art in California. The collection is particularly strong in San Francisco Bay Area art, landscape painting from 1850 to 1880, photography, California Impressionism, the California Decorative Style in painting and the decorative arts, Abstract Expressionist painting and ceramics, and contemporary painting and sculpture. Artists exhibited include Thomas Hill, William Keith, Eadweard Muybridge, Arthur and Lucia Mathews, Dorothea Lange, Selden Gile, Joan Brown, Manuel Neri, Raymond Saunders, Lia Cook, Sam Maloof, Stephen DeStaebler, Deborah Butterfield, Peter Voulkos, Viola Frey, Ruth Asawa, Marvin Lipofsky, Richard Diebenkorn, Robert Hudson.

Hours: Wed.-Sat. 10:00-5:00, Sun. 12:00-7:00. Admission: $5 general; $3 65 and over and students; 5 and under and members free. Free to all on Sun. 4-7 p.m.

SAN DIEGO HISTORICAL SOCIETY
P.O. Box 81825
San Diego, CA 92138
Tel. 619-232-6203

The Society operates four museums (days and hours vary, please call):
Headquarters:
MUSEUM OF SAN DIEGO
HISTORY AND RESEARCH ARCHIVES
1649 El Prado, Balboa Park, San Diego, CA 92101 (619) 232-6203
JUNIPERO SERRA MUSEUM
2727 Presidio Dr., Presidio Park, San Diego, CA 92110 (619) 297-3258
VILLA MONTEZUMA (Jesse Shepard House, 1887) 1925 K Street, San Diego, CA 92102 (619) 239-2211
GEORGE & ANNA GUNN MARSTON HOUSE (1905) 3525 Seventh Ave., San Diego, CA 92103 (619) 298-3142

Collection: The Society's collections, which cover primarily the regional history of San Diego County, are displayed in four architecturally significant buildings. The art collection includes portraits and pieces of an historical nature as well as representative works of art by a broad range of artists who lived or worked in the San Diego area from the mid 19th century to the present. Currently numbering about 900 pieces, the art collection includes paintings, sculpture, prints and drawings. In addition, the collection also contains artists' working models and sketches, tools and equipment, studio effects, personal archives, photographs and oral histories. Among the highlights of the collection are Arthur Putnam's two major sculptures, W.P.A. murals by Belle Baranceanu and Charles Reiffel, and award winning artworks by Alfred Mitchell, Anni Baldaugh, Donal Hord and Ethel Greene.

THE SAN DIEGO MUSEUM OF ART
Balboa Park, P.O. Box 2107
San Diego, CA 92112-2107
Tel. 619-232-7931

The San Diego Museum of Art is a general museum offering a schedule of programs relative to its collections and special exhibitions. European old masters, American paintings, and Asian arts highlight the permanent collections. Over 200 years of American paintings range from 1761 to the present, with outstanding examples by George Bellows, Joseph Blackburn, Charles E. Burchfield, William Merritt Chase, Stuart Davis, Asher B. Durand, Thomas Eakins, Robert Henri, George Inness, Eastman Johnson, Thomas Moran, Georgia O'Keeffe, Raphaelle Peale, Ammi Phillips, Morgan Russell, John Sloan, Thomas Sully and Andrew Wyeth. Contemporary American Art includes a recent gift from the Frederick R. Weisman Art Foundation of 33 works by practicing California artists.

Hours: Tues.-Sun., 10:00-4:30; closed Monday and major holidays. *Admission:* Tues.-Thurs., adults $7.00, seniors and college students $5.00, military $4.00, students aged 6-17 $2.00, children under 6 free. Add $1.00 for Fri.-Sun. admission. Cafe, lunch 11:00 a.m. to 2:00 p.m.; dinner 5:00 p.m. to 8 p.m. Tues.-Sun. 619-696-1990. The museum store is open during museum hours and is free to the public.

UNIVERSITY ART MUSEUM
UNIVERSITY OF CALIFORNIA
Santa Barbara, CA 93106
Tel. 805-893-2951

The University Art Museum collects works of art and architectural drawings and archival materials. Of special note among the 6500 art objects are the Morgenroth Collection of Renaissance Medals and Plaquettes, the Sedgwick Collection of 20 Old Master Paintings, the Feitelson Collection of Old Master Drawings, the Trevey Collection of American Prints, and the Fernand Lungren Bequest. In addition, the collection is strong in African, contemporary, and graphic arts. The Architectural Drawing Collection, one of the largest in the country, contains over 350,000 drawings, plans, models, and related materials, and specializes in the history of Southern California architecture. The Museum features a varied program of changing exhibitions throughout the year.

Hours: Tues.-Sat. 10:00-4:00; Sun., Holidays 1:00-5:00. Closed on Mondays and major holidays. Free admission.

SANTA BARBARA MUSEUM OF ART
1130 State Street
Santa Barbara, CA 93101
Tel: 805-963-4364

One of the nation's outstanding regional museums, with important holdings of American art, featuring examples by O'Keeffe, Eakins, Sargent and Hopper; 19th Century French art, including Impressionist works by Monet; watercolors by Chagall; and Asian art, classical antiquities, photography, contemporary art, modern European art, and prints and drawings. Special exhibitions throughout the year explore a variety of themes. Docents offer gallery tours at 1 p.m. Tues.-Sun., in-depth focus tours of special shows and the permanent collections at noon Wed. & Sat., and a monthly bilingual (Spanish/English) tour. The museum also offers a variety of programs, such as films, slide lectures, concerts, art classes and travel opportunities.

Hours & Admission: Tues.-Wed. and Fri.-Sat., 11:00-5:00, Thurs. 11:00-9:00, Sun. noon-5:00. $4, adults; $3, seniors; $1.50, children 6-16; children under 6 and museum members, free. No charge on Thurs. & first Sun. of the month.

EUGENE NEUHAUS, Landcape, n.d.
Oil on canvas, 31 x 35½ inches

Credits

Alexander, Peter
Van Nuys, 1987
Oil and acrylic on canvas, 60 x 66 inches
Courtesy James Corcoran Gallery, Santa Monica, CA
114

Backus, Standish, Jr.
Santa Marguerita Grade, 1939
Watercolor, 15 x 22 inches
McClelland Collection
120

Backus, Standish, Jr.
Untitled, Two Bulls, 1939
Watercolor, 15 x 21 inches
Courtesy of Maxwell Galleries, San Francisco
72

Bellows, George
Golf Course – California, 1917
Oil on canvas, 30 x 38 inches
Cincinnati Art Museum
The Edwin and Virginia Irwin Memorial
15

Bellows, George
Horses, Carmel, 1917
Oil on board, 17¾ x 22 inches
Private collection, New York
Courtesy of Spanierman Gallery, NY
127

Bellows, George
The Fisherman, 1917
Oil on canvas, 30 x 44 inches
Courtesy of Berry-Hill Galleries, New York
63

Benton, Thomas Hart
Hollywood, 1937
Oil on canvas, 53½ x 81 inches
The Nelson-Atkins Museum of Art, Kansas City, MO
Bequest of the artist
22

Bierstadt, Albert
Giant Redwood Trees of California, 1874
Oil on canvas, 52½ x 43 inches
The Berkshire Museum, Pittsfield, MA
Gift of Zenas Crane
36

Bierstadt, Albert
Lake Tahoe, Spearing Fish by Torchlight, c. 1875
Oil on canvas, 31½ x 49 inches
The Los Angeles Athletic Club
Photograph by Lawrence Reynolds
35

Bierstadt, Albert
Domes of the Yosemite, 1867
Oil on canvas, 116 x 180 inches
St. Johnsbury Athenaeum, St. Johnsbury, VT
26-27

Bierstadt, Albert
Yosemite Valley, 1868
Oil on canvas, 36 x 54 inches
The Oakland Museum
Gift of Miss Marguerite Laird in memory of
Mr. & Mrs. P. W. Laird
9

Bischoff, Elmer
Two Figures at the Seashore, 1957
Oil on canvas, 56 x 56¾ inches
Newport Harbor Art Museum
Museum purchase with a matching grant from
the National Endowment for the Arts
16

Blair, Lee
San Francisco Cable Car Celebration, c. 1938
Watercolor on paper, 15 x 21½ inches
Sally & David Martin Collection
87

Blakelock, Ralph Albert
Seal Rocks, c. 1880
Oil on canvas, 42 x 31 inches
© The Paine Art Center & Arboretum, Oshkosh, WI
Gift of Nathan and Jessie Kimberly Paine
49

Braun, Maurice
California Valley Farm, 1920
Oil on canvas, 40 x 50 inches
Collection of Joseph L. Moure
Frontispiece

Brewerton, Lt. George D.
Jornada del Muerto, 1853
Oil on canvas, 30 x 44 inches
The Oakland Museum
The Oakland Museum Kahn Collection
Photograph by M. Lee Fatherree
38

Butman, Frederick
Chinese Fishing Village
Dr. Albert Shumate Collection
Courtesy of The North Point Gallery, San Francisco
52

Butman, Frederick
Yosemite Falls, 1859
Oil on canvas, 36 x 45¼ inches
Eldon Grupp Collection
31

Cottingham, Robert
Barrera-Rosa's, 1985
Oil on canvas, 59 x 168 inches
Courtesy of Louis K. Meisel Gallery, New York
Photograph by Steve Lopez
107

Coulter, William A.
The Cliff House and Seal Rocks, 1876
Oil on canvas, 18¼ x 34¼ inches
Howard B. Schow Collection
Courtesy of The North Point Gallery, San Francisco
48

Coulter, William A.
San Francisco Fire, 1906
Oil on canvas, 60 x 120 inches
Courtesy of Maxwell Galleries, San Francisco
58-59

Craig, Tom
Into the Sun, c. 1933
Oil on canvas, 30 x 35 inches
The Buck Collection, Laguna Hills, CA
75

Diebenkorn, Richard
Sea Wall, 1957
Oil on canvas, 20 x 26 inches
Collection of Mr. & Mrs. Diebenkorn
91

Diebenkorn, Richard
Figure on a Porch, 1959
Oil on canvas, 57 x 62 inches
The Oakland Museum
Anonymous Donor Program of the
American Federation of Arts
94

Dike, Phil
View of Los Angeles (Chavez Ravine), 1943
Oil on canvas, 22 x 35 inches
The E. Gene Crain Collection, Laguna Beach, CA
84

Dixon, Willard
Petaluma Fields, 1987
Oil on canvas, 72 x 108 inches
Collection of California State Teachers Retirement
System, Sacramento, CA
Courtesy of Contemporary Realist Gallery, San Francisco
99

Doolin, James
Highway Patrol, 1986
Oil on canvas, 72 x 118 inches
Courtesy of Koplin Gallery, Santa Monica, CA
109

Doolin, James
Stairway, 1991-92
Oil on canvas, 90 x 72 inches
Courtesy of Koplin Gallery, Santa Monica, CA
112

Duvall, Fannie Eliza
Chrysanthemum Garden in Southern California, 1891
Oil on canvas, 42½ x 68¼ inches
From the lost collection of
James L. Coran and Walter A. Nelson-Rees
12

Estes, Richard
View from Twin Peaks, 1990
Oil on canvas, 36 x 72 inches
Private collection
Courtesy of Allan Stone Gallery, New York
116-117

Everett, Bruce
May Canyon, 1987
Oil on canvas, 78 x 56 inches
Courtesy of Olga Dollar Gallery, San Francisco
111

Frost, John
Artist's Wife, 1924
Oil on board, 18 x 22 inches
Firestone Collection
Courtesy of George Stern Fine Arts, Encino, CA
Half-title page

Gay, August
Woman in the Garden, c. 1923
Oil on canvas, 20 x 16 inches
Collection of Mr. & Mrs. Robert E. Aichele.
80

Gile, Selden Connor
Boat and Yellow Hills, n.d.
Oil on canvas, 30½ x 36 inches
The Oakland Museum
Gift of Dr. & Mrs. Frederick Novy, Jr.
76

Gile, Selden Connor
Ranch Scene: Hilarita Ranch, 1934
Oil on canvas, 34 x 40 inches
From the lost collection of
James L. Coran and Walter A. Nelson-Rees
Front jacket

Gile, Selden Connor
The Soil, 1927
Oil on canvas, 30 x 36 inches
Private collection
Photograph by Cecile Keefe
77

Ginder, Robert
Blue House, 1992
Oil and gold leaf on wood, 40½ x 53 inches
Courtesy O.K. Harris Works of Art, NY
104

Hahn, William
Harvest Time, 1875
Oil on canvas, 36 x 70 inches
The Fine Arts Museums of San Francisco
Gift of Mrs. Harold R. McKinnon &
Mrs. Harry L. Brown
46-47

Hahn, William
Market Scene, Sansome Street, San Francisco, 1872
Oil on canvas, 60 x 96 inches
Crocker Art Museum, Sacramento, CA
E. B. Crocker Collection
50-51

Hahn, William
Sacramento Railroad Station, 1874
Oil on canvas mounted on board, 53¾ x 87¾ inches
The Fine Arts Museums of San Francisco
Gift of the M. H. de Young Endowment Fund
21

Hansen, Armin C.
Men of the Sea, n.d.
Oil on canvas, 51⅜ x 57 inches
Monterey Peninsula Museum of Art
Gift of Jane and Justin Dart
62

Harmer, Alexander
Battle of the Flowers, Fleet Festival, 1908
Oil on canvas, 20 x 36 inches
Santa Barbara Historical Society, Santa Barbara, CA
56

Hassam, Childe
The Silver Veil and the Golden Gate, 1914
Oil on canvas, 29⅝ x 31⅛ inches
Valparaiso University Museum of Art, Valparaiso, IN
Sloan Collection of American Paintings
61

Hill, Thomas
Great Canyon of the Sierra, Yosemite, 1871
Oil on canvas, 72 x 120 inches
Crocker Art Museum, Sacramento, CA
E. B. Crocker Collection
28-29

Hockney, David
A Bigger Splash, 1967
Acrylic on canvas, 96 x 96 inches
Tate Gallery, London © David Hockney
93

Hockney, David
Mulholland Drive: The Road to the Studio, 1980
Acrylic on 2 canvases, 86 x 243 inches
Los Angeles County Museum of Art
Purchased with funds provided by the
F. Patrick Burns bequest © David Hockney
102-103

Hopkins, Stephen
Denny's Arco, 1987
Oil with alkyd medium on linen, 32½ x 71½ inches
Courtesy of Modernism, San Francisco
106

Inness, George
California, 1894
Oil on canvas, 60 x 48 inches
The Oakland Museum
Gift of the Estate of Helen Hathaway White and the
Women's Board, Oakland Museum Association
34

Keith, William
Sand Dunes and Fog, San Francisco, early 1880s
Oil on canvas mounted on composition board,
15¼ x 25¼ inches
Saint Mary's College of California
Gift of Mary B. Alexander in memory of
her husband, Wallace Alexander
41

Keith, William
San Anselmo Valley Near San Rafael, 1869
Oil on canvas, 24 x 36¼ inches
Saint Mary's College of California
Gift of Adrienne Williams, 1957
40

Kleitsch, Joseph
Old Laguna, 1924
Oil on canvas, 36 x 40 inches
Collection of Dr. and Mrs. Edward H. Boseker,
Santa Ana, CA
19

Kosa, Emil Jean, Jr.
Untitled (Farmhouse), n.d.
Oil on canvas, 22 x 28 inches
Collection of James and Linda Ries
6

Kosa, Emil Jean, Jr.
*Untitled (Los Angeles City Hall and Times Building
from Bunker Hill),* c. 1931
Watercolor on paper, 14½ x 20¾ inches
Collection of James and Linda Ries
85

GEORGE BELLOWS, Horses, Carmel, 1917, Oil on board, 17¾ x 22 inches

Lagodich, Simeon
Lake Hollywood, Late Afternoon, 1988
Oil on canvas, 22 x 50 inches
Collection of Gibson, Dunn & Crutcher, Irvine, CA
Courtesy of Tatistcheff Gallery, Santa Monica, CA
96-97

Lee, Joseph
*Ralston Hall and its Grounds,
San Mateo County,* c. 1865-66
Oil on canvas, 30 x 47⅝ inches
Hirschl & Adler Galleries, New York
Courtesy of Montgomery Gallery, San Francisco
44-45

Lungren, Fernand
Death Valley, Dante's View, n.d.
Oil on canvas, 26 x 60 inches
University Art Museum, University of California,
Santa Barbara, Fernand Lungren bequest
39

Marple, William
Mount Tamalpais from Napa Slough, 1869
Oil on canvas, 20 x 32 inches
California Historical Society, San Francisco
43

Mathews, Arthur F.
Monterey Cypress #3, 1933
Oil on canvas, 38¼ x 34¼ inches
The Oakland Museum
Gift of Concours d'Antiques, Art Guild
The Oakland Museum Association
11

McIlvaine, William
Panning Gold, California, n.d.
Watercolor over pencil on paper, 18⅛ x 27½ inches
Museum of Fine Arts, Boston
M. & M. Karolik Collection
33

Miller, Barse
Factory Town, 1946
Oil on canvas, 26 x 36 inches
The Toledo Museum of Art, Toledo, OH
Museum Purchase Fund
89

Mitchell, Alfred R.
Flower Show in Balboa Park, c. 1925
Oil on canvas, 18 x 20 inches

San Diego Historical Society
Gift of Dorothea W. Mitchell, 1979
81

Nahl, Charles & Wenderoth, Frederick A.
Miners in the Sierras, 1851-52
Oil on canvas, 54¼ x 67 inches
National Museum of American Art, DC
Photograph courtesy of Art Resource, NY
32

Neuhaus, Eugene
Landscape, n.d.
Oil on canvas, 31 x 35½ inches
Santa Barbara Museum of Art
Anonymous donor
123

Oldfield, Otis
Telegraph Hill, c. 1927
Oil on canvas, 40 x 33 inches
The Delman Collection, San Francisco
88

Paradise, Phil
Ranch Near San Luis Obispo, Evening Light, 1935
Oil on canvas, 28 x 34 inches
The Buck Collection, Laguna Hills, CA ·
73

Park, David
Four Men, 1958
Oil on canvas, 57 x 92 inches
Whitney Museum of American Art
Purchase, with funds from an anonymous donor
Photograph by Robert E. Mates, NJ
92

Penezic, Relja
Highway One #1, 1992
Oil on canvas, 24 x 36 inches
Collection of Hancock, Rothert & Bunshoft, San Francisc
Courtesy of Contemporary Realist Gallery, San Francisco
110

Preston, Astrid
Mountain Path, 1989
Oil on canvas, 96 x 72 inches
Courtesy of the Jan Turner Gallery
Photograph by James Franklin
113

Redmond, Granville
Silver and Gold, n.d.
Oil on canvas, 30 x 40 inches

Laguna Art Museum, Laguna Beach, CA
Gift of Mr. and Mrs. J. G. Redmond
7

Redmond, Granville
California Poppy Field, c. 1926
Oil on canvas, 40¼ x 60¼ inches
Los Angeles County Museum of Art
Gift of Raymond Griffith
78

Reiffel, Charles
In the San Felipe Valley, n.d.
Oil on canvas, 33½ x 36½ inches
San Diego Museum of Art
69

Ritschel, William
Mammoth Cove, n.d.
Oil on canvas, 50 x 60¼ inches
Monterey Peninsula Museum of Art
Gift of the Ritschel Memorial Trust
66

Rix, Julian
*Landscape (Twilight Scene with Stream
and Redwood Trees)*, n.d.
Oil on canvas, 83½ x 46½ inches
The Oakland Museum
Bequest of Dr. Cecil E. Nixon
37

Rix, Julian
Upper Sacramento River, c. 1876
Oil on canvas, 30 x 60 inches
Courtesy of Garzoli Gallery, San Rafael, CA
Title page

Romero, Frank
Angelino Heights, 1986
Oil on canvas, 48 x 60 inches
Collection of Kathy Williams
105

Rose, Guy
Laguna Eucalyptus, c. 1916-17
Oil on canvas, 39½ x 30 inches
The Irvine Museum, Irvine, CA
10

Rose, Guy
Mist Over Point Lobos, c. 1918
Oil on canvas, 28½ x 24 inches
Fleischer Museum, Scottsdale, AZ
17

Ruscha, Edward
Standard Station with 10 ¢ Western, 1963
Oil on canvas, 65¾ x 122¼ inches
Private collection
23

Sample, Paul
Celebration, 1933
Oil on canvas, 40 x 48 inches
Collection of Paula and Irving Glick
82

Sheets, Millard
Old Mill, Big Sur, 1933
Watercolor on paper, 22 x 30 inches
The E. Gene Crain Collection, Laguna Beach, CA
65

Sheets, Millard
Tenement Flats (Family Flats), 1934
Oil on canvas, 40¼ x 50¼ inches
National Museum of American Art, D. C.
Photograph courtesy of Art Resource, NY
83

Smith, Alexis
Same Old Paradise, 1987
Mixed media installation, 20 x 60 feet
Courtesy of Margo Leavin Gallery, Los Angeles
Photograph by Peter Muscato
14

Thiebaud, Wayne
*24th Street Intersection
(Twenty-fourth Street Ridge)*, 1977
Oil on canvas, 35⅛ x 48 inches
Private collection
101

Thiebaud, Wayne
Urban Freeways, 1979-1980
Oil on canvas, 44⅜ x 36⅛ inches
Private collection
100

Tirrell, George
*View of Sacramento, California, from
across the Sacramento River,*, c. 1855-60
Oil on canvas, 27 x 47¾ inches
Museum of Fine Arts, Boston
Gift of Maxim Karolik to the Karolik Collection
of American Paintings, 1815-1865
20

Wachtel, Elmer
Capistrano Mission, c. 1900
Oil on canvas, 15 x 25½ inches
Fleischer Museum, Scottsdale, AZ
55

Walker, James
Cattle Drive No. 1, c. 1877
Oil on canvas, 30¼ x 50 inches
California Historical Society, San Francisco
57

Welch, Thaddeus
Landscape with Cows, 1906
Oil on canvas, 20 x 36 inches
San Diego Museum of Art
Gift of Mr. Robert Letts Jones
13

Weeks, James
*Santa Monica Easter Sunday
(Models on the Terrace)*, 1967-69-71-73
Acrylic on canvas, 69¾ x 90 inches
The Herbert W. Plimpton Foundation
on extended loan to the Rose Art Museum
Brandeis University, Waltham, MA
95

Wendt, William
Where Nature's God Hath Wrought, 1925
Oil on canvas, 50½ x 60 inches
Los Angeles County Museum of Art
Mr. & Mrs. Allan C. Balch Collection
70

Wonner, Paul
Flowers, Watches, Dark Day, 1991
Acrylic on canvas, 48 x 48 inches
Kansas City Art Institute
Mary and Crosby Kemper Collection
Gift of the William T. Kemper Foundation
Photograph courtesy of Coe Kerr Gallery, New York
128

Wood, Nicola
'60 Chevy, 1991
Oil on canvas, 36 x 60 inches
Courtesy of Sherry Frumkin Gallery, Santa Monica, CA
108

Wores, Theodore
New Year's Day in San Francisco's Chinatown, 1881
Oil on canvas, 29 x 22 inches
Collection of Drs. Ben & A. Jess Shenson
53

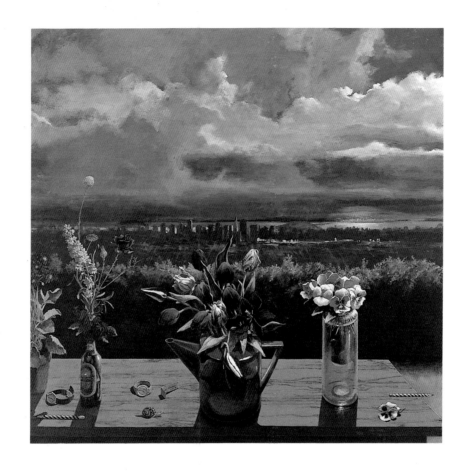

EVERY NIGHT,

at the end of America

We taste our wine, looking at the Pacific.

How sad it is, the end of America!

LOUIS SIMPSON, *Lines Written Near San Francisco*, 1963

PAUL WONNER, Flowers, Watches, Dark Day, 1991, Acrylic on canvas, 48 x 48 inches